To Bill,

Preserve the past,
Protect the future!.

Doug Stephens

2006

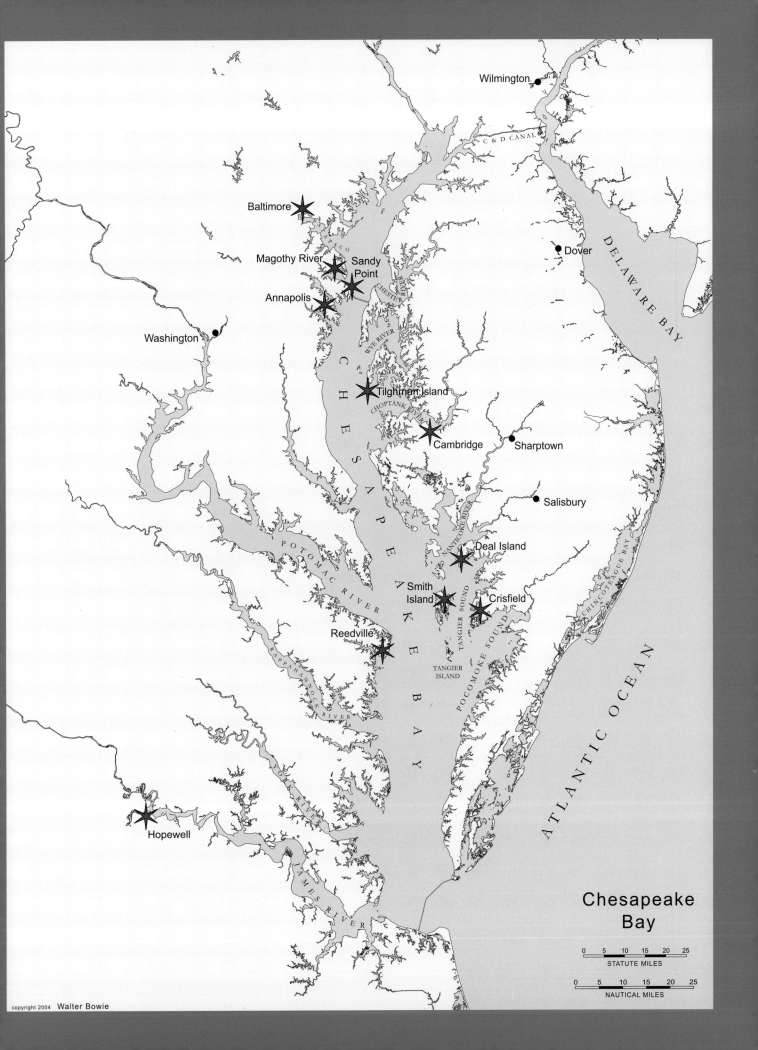

Wilmington

C & D CANAL

DELAWARE BAY

Baltimore

Dover

Magothy River

Sandy
Point

PATAPSCO

CHESTER

Annapolis

WYE RIVER

Washington

C
H
E
S
A
P
E
A
K
E

Tilghman Island

CHOPTANK RIVER

Cambridge

Sharptown

Salisbury

NANTICOKE RIVER

POTOMAC RIVER

Deal Island

CHINCOTEAGUE BAY

Smith
Island

TANGIER SOUND

Crisfield

RAPPAHANNOCK RIVER

Reedville

TANGIER
ISLAND

POCOMOKE SOUND

B
A
Y

ATLANTIC OCEAN

YORK RIVER

Hopewell

JAMES RIVER

Chesapeake
Bay

0 5 10 15 20 25
STATUTE MILES

0 5 10 15 20 25
NAUTICAL MILES

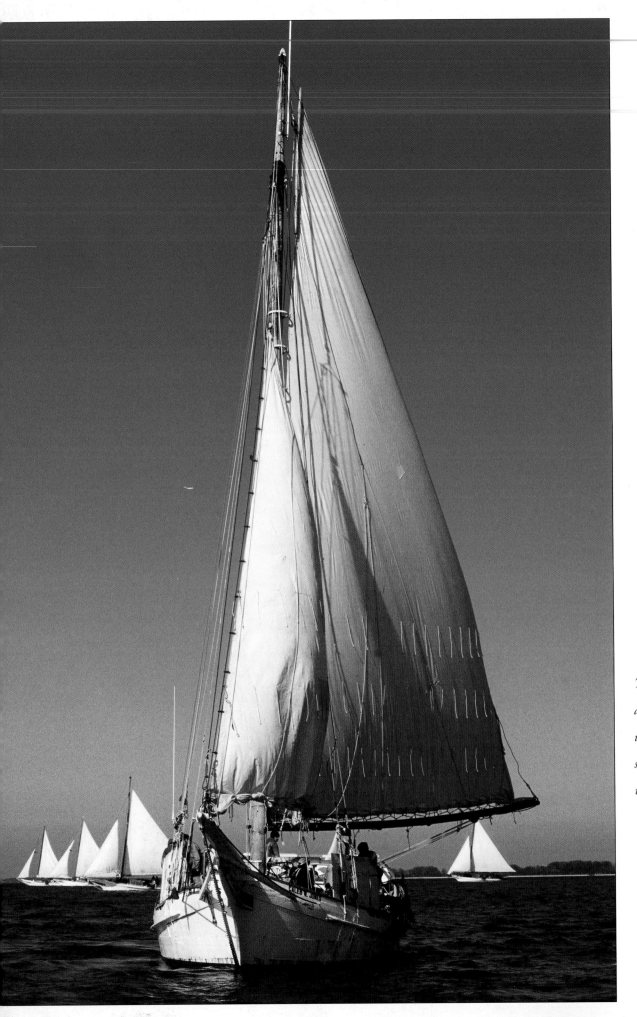

Throughout history, men and women have braved unpredictable winds to sail the seas of this great water planet, Earth.

Workin' With the Wind

by Doug Stephens

Photography by Doug Stephens

Factor Press • P.O. Box 222 • Salisbury, MD 21803 • 2004

Publisher's Cataloging-in-Publication data
Stephens, Douglas R. *Workin' With the Wind*

ISBN: 1-887650-41-5

144 p. 1.9 cm.

1. Skipjacks. 2. Oyster fisheries—Chesapeake Bay (MD
and VA). I. Title VM431.S74 2004

Layout and Design
Christopher Nelson, Nelson Design

Dedication

In loving memory of my mother, Laurie,

for her unwavering encouragement and

support, and, most importantly,

for allowing me to be me.

Acknowledgments

This is the story of the Skipjacks, America's only working commercial sailing vessels, and the watermen who sail them. My deepest thanks to:

Captain Clifton Webster
Captain Caleb W. Jones Jr.
Captain Elden Willing Jr.
Captain Harry Windsor
Jim Coffman
Frederick Tilp
Captain Dicky Webster
Captain Jessie Brymer
Captain Jack Willing
Captain Robert "Nussie" Webster
Don Fountain

Special thanks to Captain Dicky Webster for patiently answering all my questions and for allowing me to spend so much time with him and his boat, and for teaching me.

And special thanks to my sister, Victoria, for her support, enthusiasm, and editing skills.

Contents

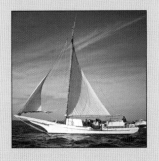

One small group of watermen on the Chesapeake has learned to harness this force we call wind. These watermen and their work boats, known as Skipjacks, use wind power to fill their sails and pull their dredges across the bottom of the bay in search of oysters. They are seafarers who have developed a type of kinship with the wind, and for many generations this has been so.

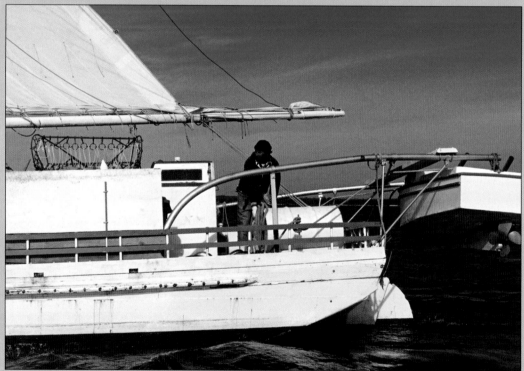

One

First Day

In the autumn of 1983, as my education at Salisbury State College was coming to an end, I began to see how the many subjects and ideas to which I had been exposed would affect the rest of my life. One subject in particular had a profound impact on me. It was photography. It taught me to appreciate the diversity and distinctive beauty of the Eastern Shore. More importantly, photography gave my life a powerful sense of direction.

One afternoon during my final semester, a fishing buddy, Jim Coffman, told me he was going to Chesapeake Appreciation Days at Sandy Point State Park. He had an opportunity to sail on a Skipjack in the races held there. I had heard about Skipjacks, but knew very little about them. Jim explained that a fishing party boat captain named Dicky Webster was also the owner of the *Caleb W. Jones,* the boat he would sail on.

The thought of sailing in a race on Chesapeake Bay excited me.

"When is it?" I asked.

"Halloween weekend," Jim replied.

Jim and I have been friends for many years, so he didn't have to ask. Jim knew I was interested. He continued, "Don Fountain and I are going down to Wenona Thursday to help Captain Dicky finish up some electrical work on the *Caleb.* Why don't you meet us down there and check it out?" Fountain is also a good friend.

"I'll be there," I said, with no doubt in my mind.

It was a breezy autumn afternoon the day I arrived at Wenona Harbor to meet Captain Dicky Webster. The sky was an intense blue, and there were several puffy white clouds to the east. A small white building with a green roof held a sign, "Shirley's Shack—bait, soft crabs, peelers." Everywhere I looked there were boats of all sizes and shapes. But it was the larger wooden boats with the tall masts that stood out, and my eyes focused in their direction.

The harbor was not busy. I later learned that this was the time of year when the oyster tongers were already out working, and the few people in the harbor were the Skipjack captains and crews getting ready for the dredging season. By law, tongers can start catching oysters six weeks before the dredgers can. Nothing pretentious about this harbor. It was not built for tourists but for working watermen.

I drove off the paved parking lot, past the boat ramp and around to where I saw some men working on a Skipjack. I could hear the oyster shells that filled the potholes crunching underneath my tires. As I stepped out of my truck, I looked at the name on the boat's stern—"Cal b W. Jones"—The "e" in *Caleb* was missing. I noticed a slight chill in the air coming off Tangier Sound, and the smell of salt water. Seagulls screeched overhead.

I stepped aboard the *Caleb* for the first time. Captain Dicky, Jim, and Fountain were installing the CB and VHF radios. (We call Don Fountain just "Fountain" sometimes.) Captain Dicky looked to be in his early forties and was a good six feet tall with broad shoulders. He looked strong. His face was darkened by many long days in the sun. He had his work coveralls on and a white hat that showed his fingerprints from bending the brim down to his liking.

There were brief introductions and they went right back to work preparing for the upcoming sailboat races and the new oyster season. I felt their sense of urgency. "Dicky sails for Sandy Point tomorrow morning," Jim explained.

Jim has a real knack for working on boats, and he always seems to make himself available to help Dicky or me when we have problems with our boats. His passion for fishing rivals Don Fountain's.

An opportunity for me to help occurred quickly. A hole had to be drilled in the cabin wall to allow the end of the antenna wire to pass through it. The problem was, no one had a drill handy—and there wasn't any electricity available even if we'd had a drill. I went to my truck and pulled out a hand auger and thought, "This just might do the job." It did, and from that point forward, there was a friendly acceptance of a stranger aboard the *Caleb W. Jones.*

"Who wants to attach the new antenna to the top of the mast?" Captain Dicky asked. I looked up and tried to imagine what it would be like perched 60 feet up from the deck. I climbed many a tree in my day, but never one without limbs. There could be some interesting pictures taken from that viewpoint, I thought.

After a little hesitation, Don Fountain spoke up. "I'll do it, Dicky." Dicky had Don seated on the tiny board called the bos'n's chair so fast he had little time to change his mind.

"No problem," he said with a wide grin.

Dicky handed Don the new antenna and some tools and it took all three of us to hoist Fountain up the mast. When he reached the top, we tied him off and let him go to work.

"Don't stand underneath `im," warned Dicky. "A wrench fallin' from up there could do some damage."

One of Dicky's crewmen showed up. He and Dicky went to work making some last minute adjustments to the little boat hanging from the stern of the *Caleb.* Jim worked on the interior connections of the radios while Don secured the antenna to the top of the mast—not an easy task. I looked around the marina and took a few pictures. After about thirty minutes, Don signaled he was ready to come down.

Don, genuinely glad to be back on deck, looked slightly stressed. "Boys, she's a little breezy up yonder, and there ain't much to hold on to, either," he commented.

Something happened next that I would see over and over during the time I spent with the watermen.

Art Daniels, Dicky's uncle and captain of a Skipjack called *The City of Crisfield*, came over and asked Dicky for some help. He, too, was preparing for the trip up the bay to Sandy Point. The tide was down and he needed a pull to get his boat out of the mud in the shallow cove and into deeper water. Without hesitation, Dicky headed for his fishing party boat, the *Standor III*. Don was right behind him, and so was I, camera in hand.

When we got close enough, Don tossed a heavy rope to a crewman aboard *The City of Crisfield*, and the crewman secured it to the bow. Don tied the other end to the stern of the *Standor*.

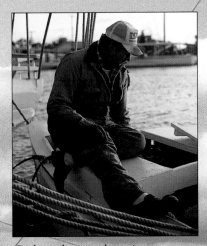

Dicky makes some last minute adjustments to the little boat hanging from the stern of the Caleb.

"Boys, she's a little breezy up yonder, and there ain't much to hold on to, either."

11

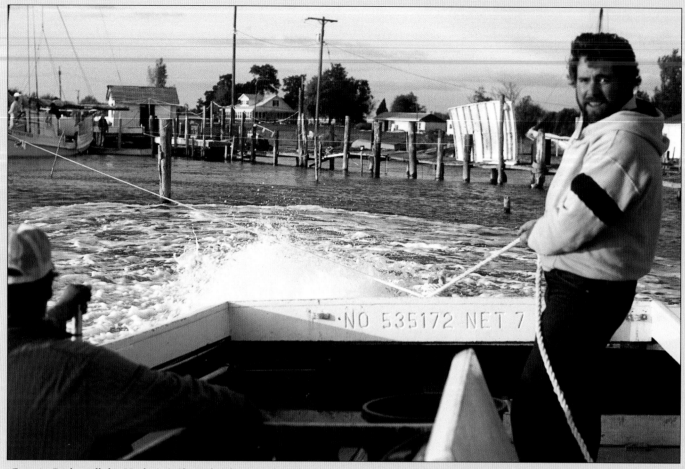

Captain Dicky pulls his Uncle Art's Skipjack, The City of Crisfield, off the mud with his fishing party boat, the Standor III.

Captain Dicky slowly increased the throttle of the *Standor*, and the rope pulled tight. The water began to churn furiously as the engine began to race. *The City of Crisfield* didn't budge. Dicky changed his angle and gave it a second try. Again he slowly increased the throttle and again the water bubbled and the motor wailed. This time I could hear the rope stretching. I could feel the energy in it as it was put to the test. The rope looked as though it could snap and cut a man in half!

The *Standor's* engine ran wide open for what felt like an eternity, but she wasn't moving. *The City of Crisfield* was "fast" in the mud, as Dicky would say. When the Skipjack finally began to move, the *Standor's* engine was screaming. It wasn't long after that she was afloat.

Many times in the months and years that followed, I have seen Dicky, or his friends, or just about any of the other watermen I've come to know, stop what they were doing to help someone in need. This is a common trait among watermen.

What an exciting day! I looked forward with anticipation to Saturday morning, Halloween, at Sandy Point and the annual Skipjack races that signal the beginning of a new oyster-dredging season!

Two

A Brief History

Almost an island, the Delmarva Peninsula lies approximately halfway down the eastern seaboard of the United States. It's a relatively small area of land; the peninsula measures one hundred thirty-six miles long and fifty-five miles wide at its farthest points. Known affectionately as the Eastern Shore, or simply the Shore, the Delmarva Peninsula is made up of most of the state of Delaware, a large portion of Maryland and a small piece of Virginia. Thus, Del-Mar-Va.

The Eastern Shore is rich in both history and natural beauty. It is blessed with fertile fields and bountiful waters and is inhabited by good, hard-working people. It is a unique place where tradition and honor live side by side with progress and change. The Eastern Shore—a land greatly influenced by the life-sustaining waters of the Chesapeake Bay and its tributaries.

The accent of the people on the Eastern Shore is a mixture of Elizabethan English, Southern drawl and Delmarva colloquialisms. It varies from county to county and even from farmer to fisherman, and gets heavier and thicker as one travels away from the larger towns and into the fishing villages and watermen's harbors, where *water* is pronounced *wooter*, *oyster* is pronounced *arester*, *Maryland* is *Merlin*, *right wold* means *right wild* (very wild) and so on.

Because the peninsula has limited access, the accent and colloquialisms have been passed down from generation to generation, and remain an appealing aspect of the area.

The peninsula is separated from the mainland to the north by the Chesapeake and Delaware Canal. Otherwise known as the C & D Canal, this man-made waterway was built to connect the Chesapeake Bay to the Delaware River, thus providing sheltered navigation and an alternate shipping route for sea-going vessels sailing to or from the Port of Baltimore. To the east of the peninsula lie a picturesque chain of barrier islands, a wonderful sandy seashore, and the Atlantic Ocean. Separating the Eastern Shore from the mainland to the south and west is the Chesapeake Bay, home to the only fleet of commercial fishing vessels under sail in America, the Skipjacks.

These boats are the last in a long line of wind powered oyster dredge boats that originated and evolved along the shores of the Chesapeake Bay and its many tributaries. The durable little fleet of working sailboats has come to symbolize this entire area's rich and colorful nautical heritage. In June, 1985, Governor Harry Hughes of Maryland declared the Skipjack to be Maryland's official state boat. Unfortunately, these celebrated sailboats, with all their strength, endurance, and beauty, are now in danger of becoming just a memory. One by one, they are vanishing. And vanishing with them is the unique way of life of the independent seafaring people who have sailed them for generations.

Rivers

Throughout the Eastern Shore, there are seventeen navigable rivers. While extending the bay's waters, these rivers twist and turn, winding their way through the Shore, dividing it into little pieces as they go. These fresh water rivers flow into and consequently mix with the saltier waters entering the bay from the Atlantic Ocean. There are also hundreds of creeks, streams, and ditches that extend the tidal area of the Chesapeake Bay even farther. The result is miles and miles of shoreline, vast areas of marshland, seemingly endless waterways, countless islands, and a multitude of smaller bays and safe natural harbors.

Along the shoreline

Mallards in flight

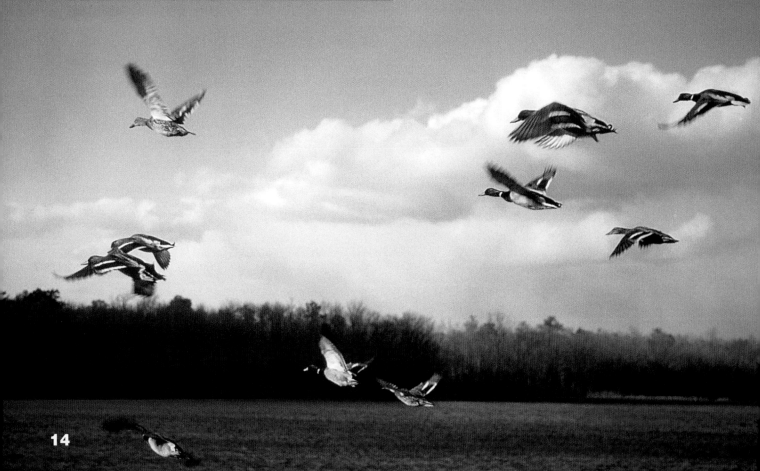

14

Watermen

It should be no surprise, then, to learn that the Eastern Shore is home to a distinct group of people who make their living from the bay and its tributaries. These men and women have come to be known simply as "watermen."

On one hand, it seems to be a very fulfilling occupation. Sailing about the bay, working with Mother Nature, and harvesting her bounties (oysters, crabs, clams, and fish) must give an individual a good feeling about life. And being one's own boss helps to ensure the independence that these people so highly value. What's more, the overall pace of life appears to be more relaxed than the hustle and bustle of the outside, modern world.

On the other hand, the work is physically demanding, the days are long, and the intended catch does not willingly cooperate. To make matters more difficult, the extremes of weather can be brutal. On the water, the weather tends to be more intense than on land, be it blistering heat or extreme cold, gale winds or breathless calm. During the winter oyster season, the watermen are exposed to temperatures in the teens or below. The wind and the wet magnify the cold, and it takes a tenacious human being to endure. Wind is probably the most important element in nature that the watermen contend with. Strong winds can whip up seemingly out of nowhere. At those times, it is man against nature and man doesn't always win. At other times, slight breezes aren't enough to move even a small sailboat across the water.

Sharptown Sunset

Summer Lightning

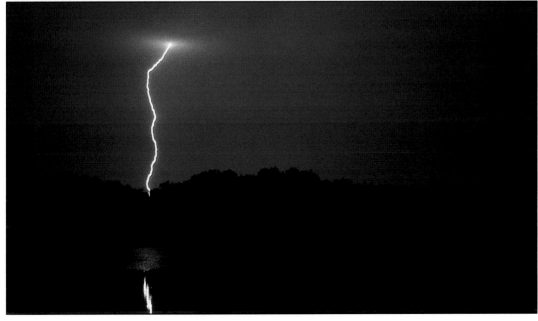

15

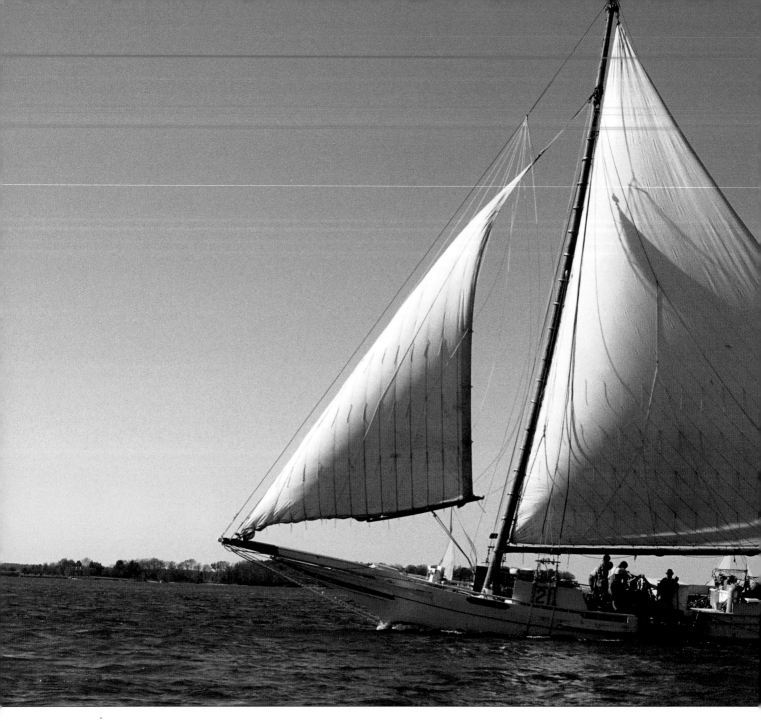

Peak

In the early 1800's, the Chesapeake Bay was at its ecological peak. Practically undisturbed by man, the Bay was clean and healthy. A rich variety of plant and animal life flourished in the unspoiled water and along the shorelines. Millions of acres of marsh grasses provided a feeding ground, nursery, habitat, and hiding place for multiple species of waterfowl, fish, crabs, clams, oysters, and more. The Chesapeake Bay was ripe for harvesting.

During the mid-1800's, the entire Bay area economy grew to depend heavily on oysters. When the dredge (a heavy, cage-like device with teeth) was imported from New England, the oyster industry was transformed. There was an economic boom and a thriving seafood industry developed. From the beginning, this industry was based primarily on the oysters and the men who made their livings harvesting them. The Chesapeake Bay was alive with activity. Sailing vessels of all sorts plied the water, dredging the floor of the Bay in search of oysters.

The wind-powered oyster dredge boats peaked during the late 1800's. In the 1884-85 season, watermen harvested a record fifteen million bushels of oysters from just the Maryland portion of the Chesapeake Bay and its tributaries. Schooners, Bugeyes, and other vessels of all kinds sailed the

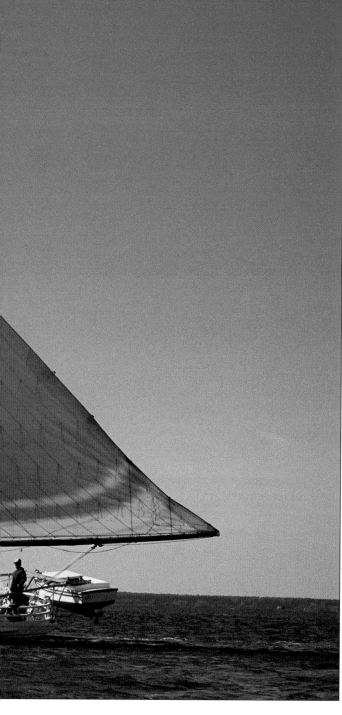

The Kathryn

Wicomico River Sunset

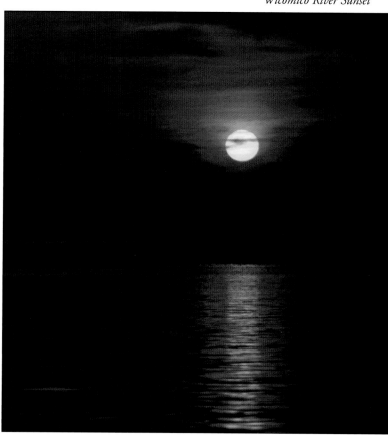

bay. But it was the Pungy (pronounced "Pun-gee"), a fore-runner of the Skipjack, that was favored for a brief period by dredgers. Much larger than the Skipjack, the Pungy resembled a scaled-down version of a Baltimore Clipper Ship. After the Civil War, Bugeyes became the preferred type over the Pungy.

During that period of abundance, Carlos and Hester Ann Jones lived in the small village of Carlos' Point, located on Smith Island in the center of the bay. On April 1, 1886, they had a son and named the boy Caleb Wesley Jones. In time, Caleb's life would mirror the rise and fall of the Chesapeake Bay oyster industry.

By the turn of the century, the Chesapeake Bay was showing signs of wear. Oyster harvests were declining because of a lack of conservation. Overfishing was taking its toll. Also, industry, agriculture, and encroaching development along the Bay's watershed began to have a negative effect on water quality.

Because of the dwindling harvests, the watermen needed a smaller, less expensive, more efficient dredge boat. They also needed a boat with a shallow draft to go after the oysters in shallower waters. As an answer to these needs, the Skipjack evolved.

◄ Oysters, the delicious bivalves

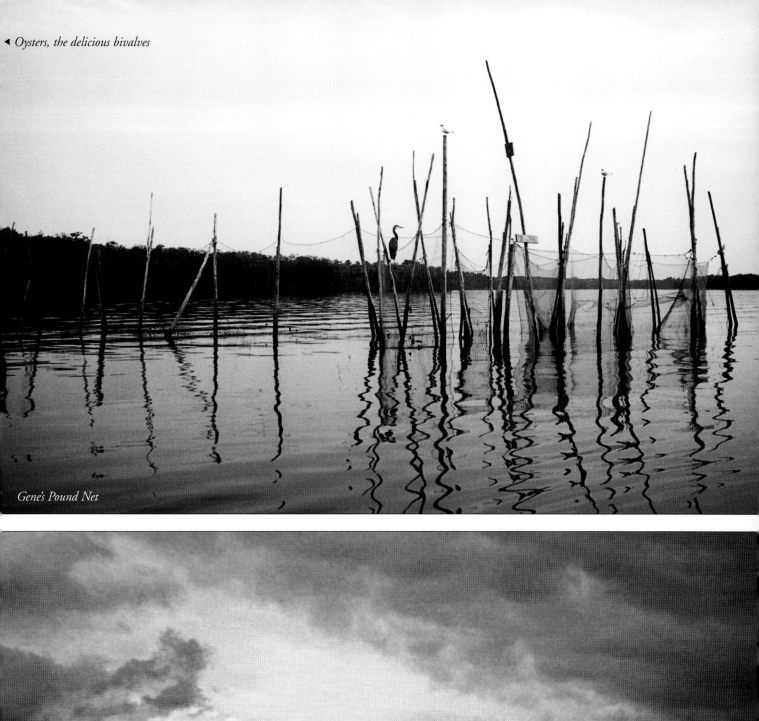

Gene's Pound Net

Storm Warning

19

Frederick Tilp of Alexandria, Virginia, sketches the Skipjack's origin, history and technical description as follows:

Maritime authorities indicate this craft was better known as a "two-sail bateau," and that the V-bottom hull was developed from flat-bottom skiffs such as the flattie or the sharpie. Originating on the Eastern Shore; an archaic word meaning, "upstart," or "inexpensive yet useful servant." The name "bateau" (French for boat) was derived from Huguenot boat builders at Ross Neck on the Little Choptank River prior to the Revolution.

The full form and sail shape of the Skipjack is attributable to economic conditions. The depressed period of the early 1890's and the decline in oyster production occurred at the same time. Skipjacks were simple in design and were therefore cheap to construct when compared to other vessels.

The Skipjack's hull was shallow, wide, and V-bottomed, and had a low angle of deadrise, raking stem, and square stern. It was fitted with a centerboard, clipperbow, longhead, carved trailboard, and bowsprit.

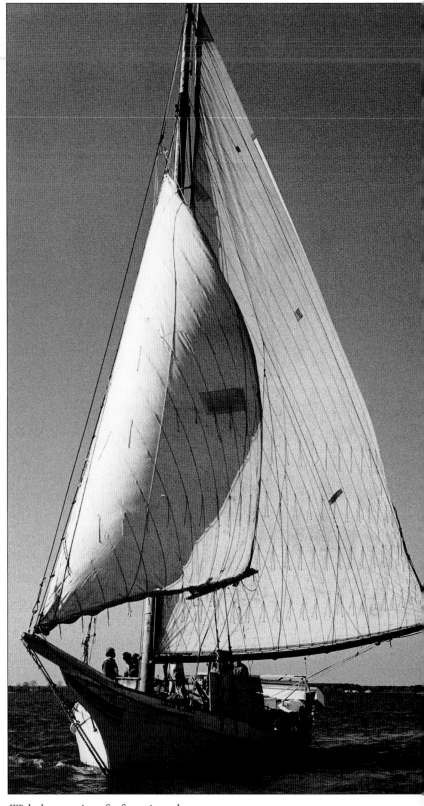

With the exception of a few minor changes, Skipjacks and the men who sail them dredge oysters the same way their ancestors did one hundred years ago.

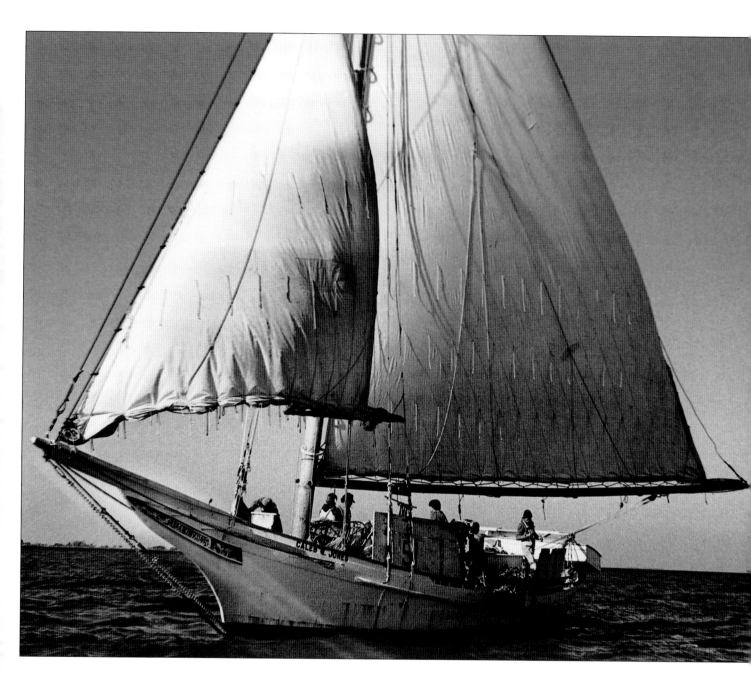

Bottom planking was laid athwartships; side planking was fore and aft with frames. One tall raking mast, set far forward, carried a jib and triangular mainsail; a cabin and sleeping quarters were added around 1890. Standing rigging with deadeyes and hemp lanyards came into use, along with increased size and wider use of power winders. Sharply raking masts, as a tradition of the Skipjack and Bugeye, had numerous advantages: more usable deck space resulted with the mast positioned well forward. The rake located the mainsails center of effort to its proper position and mast hoops tend to jamb less than on straight masts. A triangular sail on a raked mast spills wind easily, making

for steadier sailing. The center-of-effort on the sail moved very little when the sail was reefed, thus giving a minimum of lee helm and easier steering. Finally, the main halyard was installed vertically over the hatchway so that it could be used in hoisting out oysters or freight stored in the hold. When loaded with oysters, Skipjacks had a reputation for speed and weatherliness.

At the turn of the century, when Caleb W. Jones was fourteen years old, the Skipjack fleet was reaching its peak, with over 1,000 boats working the oyster bars of the Chesapeake. What a powerful sight it must have been for

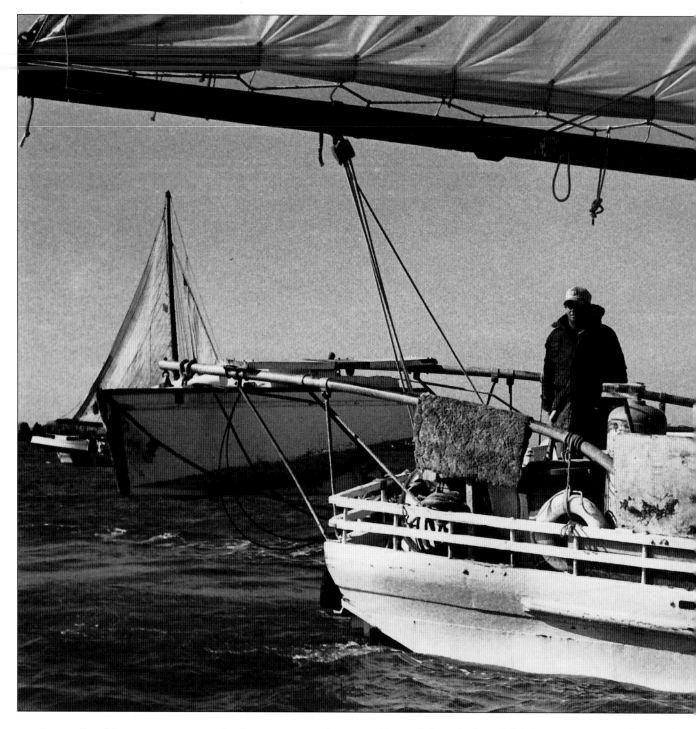

an impressionable young man to look out across the horizon and see so many working sailboats and the men aboard them, dredging oysters. This surely had a strong influence on young Caleb. And, growing up on a remote island in the middle of the Bay offered him few alternatives.

"Weren't nothin' down 'ere to do, no industries ner factories or no nothin' but work on the wooter," said Jessie Brymer, Caleb's brother-in-law and a life-long resident of Smith Island.

It wasn't long before Caleb became a man and started a family of his own. He married Charlotte Tyler, a woman from Smith Island. They had a son and named him Caleb Wesley Jones, Jr. When Caleb Jr. came of age, he, like his father and his father's father before him, became a waterman.

Sailing with Caleb was Jessie Brymer. Jessie sailed with Caleb and Caleb's son for many years aboard the boat known as the *Mary W. Sommers*. Oyster season started the last of October and continued until Christmas, and they worked near Soloman's Island mostly.

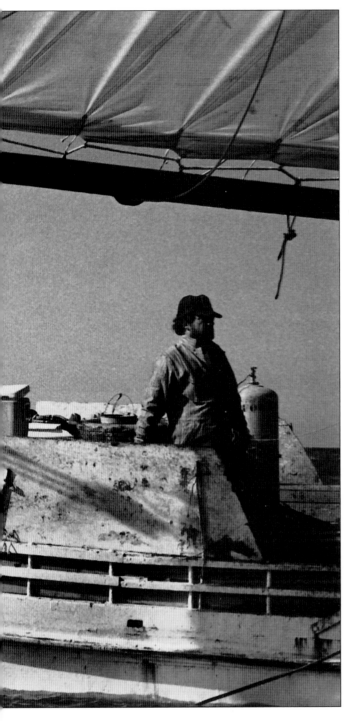

. . . If there happen to be a wind comin' up, Cap'n Caleb would say, 'We're gonna get ready to get in a jam.' He used to say that a lot. 'Get in a jam.' In the old days, our equipment wasn't the best, either. We wore cotton gloves back then. After a couple a licks, the blood would be runnin'.

"Some days we'd catch as many as five hundred bushel. But sometimes we'd go to Soloman's for two weeks and come back with a couple hundred."

When winter really moved in, the bay would occasionally freeze up and oystering came to a halt. Smith Island became inaccessible for boat traffic carrying supplies. More than once over the years, Jessie and a friend walked the seven or so miles to Crisfield on the ice and brought supplies back. Sometimes they pulled a skiff full of supplies and other times rolled barrels of flour back over the ice. After the thaw, the men would return to dredging.

In 1953, at the age of sixty-seven, Caleb Wesley Jones went to the opposite side of the bay, on the Western Shore, to a place called Reedville, Virginia. He found a man named Hubbard Rice and commissioned him to build a Skipjack. He named the boat after himself, *Caleb W. Jones.*

Caleb continued to dredge oysters with his son and brother-in-law until 1966, when, at the age of eighty, he sold his boat to a man from Hopewell, Virginia, located on the James River. As Caleb Jr. remembers it, they had to run the *Caleb's* push boat engine four or five hours up the river to the man who bought the boat. The new owner intended to convert the *Caleb* into a pleasure craft. This he never did. Caleb Jr. heard that the *Caleb* just sat for three years, during which time, she was nearly lost in a storm.

But, as good fortune would have it, in 1969, Captain Clifton Webster of Wenona, Maryland, purchased the *Caleb.* He, too, came from a long line of Chesapeake Bay watermen. That year, one of his sons, Richard "Dicky" Webster, became captain of the *Caleb.* To this day, Captain Dicky continues the tradition of *Workin' With the Wind* aboard the *Caleb W. Jones.*

"People back there studied the weather more than they do now," Jessie said. "They pretty well knew what was comin' all the time. Accordin' how the sky looked, sun dogs and all that stuff, you know. We did have a radio and a glass too. . . barometer, you know. Cap'n Caleb always said, 'You get paid back.'

"If you had a real hot summer, you gonna have a cooold winter. If you have a cam spell, you'll have some wind. I knows it. You do! You get paid. Evens 'self out pretty good.

The original inhabitants of the island called it Devil Island because it was a wild place. Surviving the elements and living with each other during the peak period of oystering was difficult. When families finally settled on the island, Presbyterian preachers brought with them the word of God, and the island's inhabitants changed the name to Deal Island.

Three

Skipjack Races

It was three o'clock in the morning, Halloween weekend, 1983. Getting up and leaving Salisbury was easy. I was pumped up with thoughts of the day to come. Jim recommended I arrive at Sandy Point early to hook up with the guys before the race. I found my way there by 6:00 a.m., just as people in the harbor and around the state park were beginning to stir.

Before I could get out of my truck, Steve Benedict and Rodney Pierson drove up behind me. The three of us located the *Caleb* and found Dicky, Jim, Fountain, and several others. We stowed our gear, which consisted of lunch and plenty of beer, and made ourselves comfortable.

It wasn't long before we were underway, headed out of the marina under the power of the push boat. The wind had been picking up all morning and was getting stronger by the minute. Dicky gave orders and the crew raised the sails. Rigging was set, the boat made ready. Captain Dicky jostled for an advantageous starting position among the other boats, whose captains were all doing the same. By then, the wind was blowing twenty to twenty-five knots. Even so, the *Caleb* stayed steady in the water.

About a dozen Skipjacks were in position to start, captains and crews tensed and ready. The starting gun sounded and the race was on. Since this was my first experience aboard the *Caleb*, I had no idea what to expect. I shot a few pictures of our competition while trying to stay out of the way. On Dicky's orders, all the riders on the boat would move from one side to the other as we changed tack. The wind continued to blow, picking up speed. Both sails filled with the breath of the earth and the rigging pulled tighter. The mast creaked and groaned. We were moving fast. White caps surrounded us.

Just as we changed direction and while I was avoiding the boom swinging across the stern, a large wave hit the bow and crashed onto the deck. "What a picture that would have been," I thought. Too bad I was busy holding on for dear life.

Captain Dicky immediately realized the *Caleb* was not responding the way she should have. Something happened to her when the big wave hit, but Dicky didn't know what. What he did know was that the race was over for us.

We limped back to the harbor, and, after we docked, Dicky assessed the damage. A piece of equipment called the bob chain had broken. This chain went from the hull at the waterline to the end of the bowsprit and is used to help equalize the pressure put on the bowsprit from the sails above.

Not long after we docked, we saw another Skipjack coming into the harbor, only this one wasn't coming in under its own power. It was under tow by the Marine Police, and water was being pumped out of a large hose coming from below decks.

The rough seas had broken a floorboard in her, and if it hadn't been for the quick response by the Marine Police, who evacuated the boat and got a pump going, she surely would have sunk.

"It could have been worse for us," I thought.

We settled down to some cold beer and the sights of Chesapeake Appreciation Days at Sandy Point State Park.

My first trip aboard the *Caleb* was very short but thoroughly exciting. Even though it ended abruptly, I knew there would be another opportunity for me to sail with Captain Dicky Webster aboard the *Caleb W. Jones*.

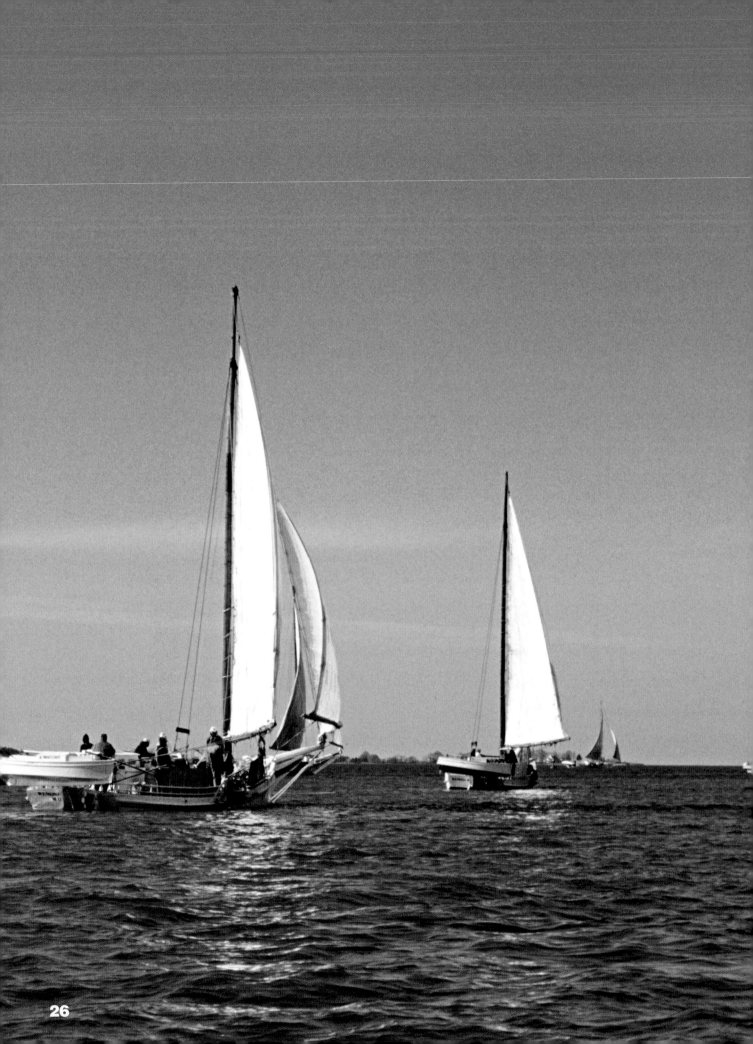

Four

On The Choptank

During my color slide class with instructor Mike Wooten at Salisbury State College, a chance meeting put me into contact with Captain Dicky Webster once again.

Mike was planning a photo shoot to update his inventory of working Skipjack pictures, and he needed an assistant to drive his boat while he worked. Mike knew I was interested in boats, especially the *Caleb*, and Chesapeake Bay, from my previous class work. He also knew I could handle a boat. So he asked me to accompany him.

We left just after daybreak. Our destination was the boat ramp at the University of Maryland's Center for Environmental and Estuarine Studies, located at Horn Point, south of Cambridge on the Choptank River. Since it was very cold and this ramp was much closer to our subjects than the Cambridge public ramp, Mike's decision to save some riding time on the water by launching his boat closer to the Skipjacks made sense to me.

The air was crisp, and the sky a brilliant blue, not a cloud in it. We launched the boat, and within minutes we saw the large white sails of the working Skipjacks. Mike prepared his equipment while I drove us closer to the action. Six or more boats were working very close together. This turned out to be good because Mike wanted to document each boat on film. We spent most of the morning cruising around with Mike giving me directions so he could shoot from certain angles.

"Get closer," he said several times. On more then one occasion, we were close enough to step aboard one of the Skipjacks as we passed by.

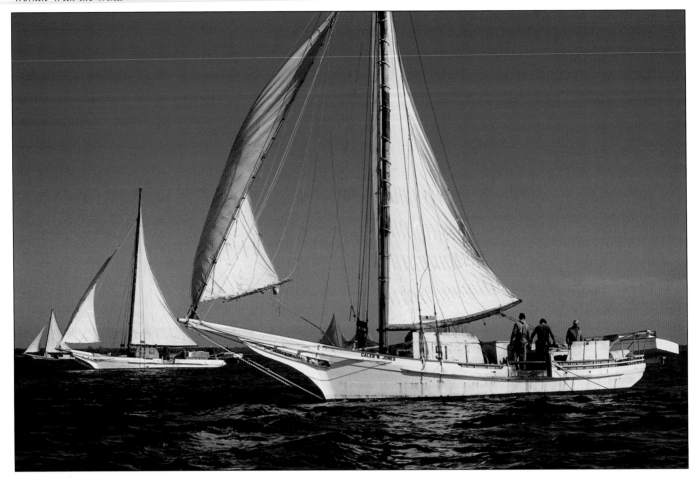

The wind filled the sails of the Skipjacks and they dragged their dredges across the oyster beds on the bottom of the river. What a sight! The large white sails set against the vivid blue sky were beautiful. On several occasions, I had the urge to pull out my camera and start shooting too. Unfortunately, that would have been difficult, since piloting Mike's boat in and out of the Skipjacks required intense concentration. The boats were so close together on the oyster bar and it was so quiet that the captains and crews could talk to one another in a normal tone of voice as they passed. The only noise came from the engines used to haul in the dredges.

I spotted the *Caleb W. Jones* and was thrilled when Mike took the helm and gave me a chance to photograph her. As I aimed my camera and began to focus, I realized that this was not going to be easy. My subject was moving, I was moving, and the small boat I was in rocked and pitched with the motion of the waves.

Mike made a number of passes around the *Caleb* so I could photograph her from several different angles, and I loved every minute of it.

DOUG STEPHENS
410-883-2274

SHORE PHOTOGRAPHY

P.O. Box 207
SHARPTOWN, MD 21861

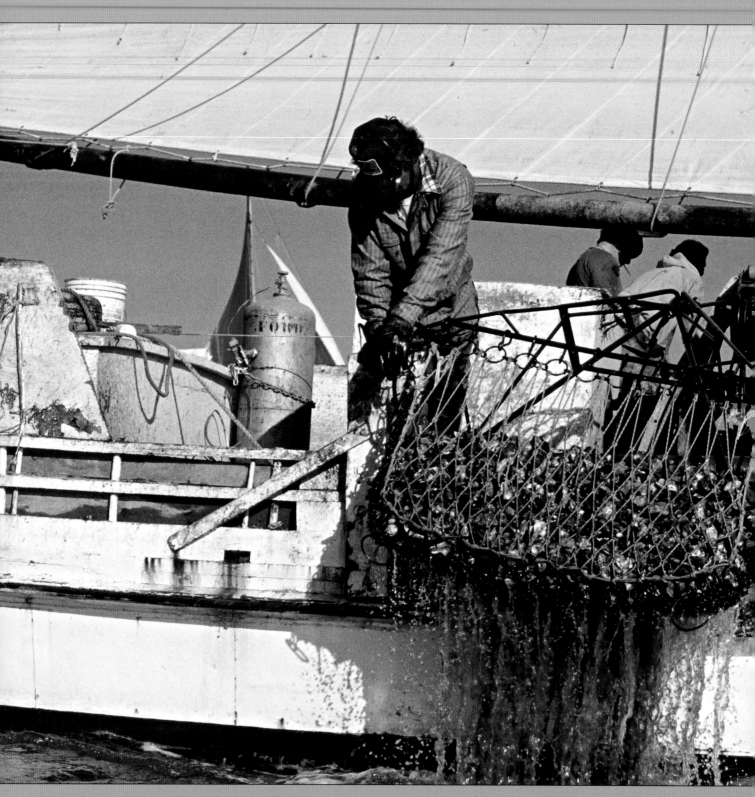

*As we approached the Caleb, the crew
was pulling in a dredge full of oysters.*

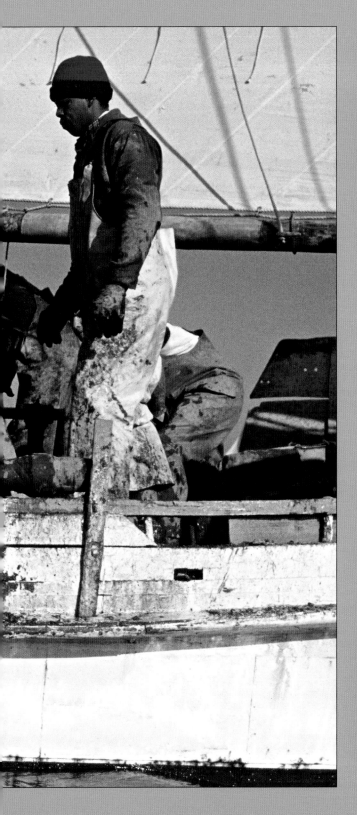

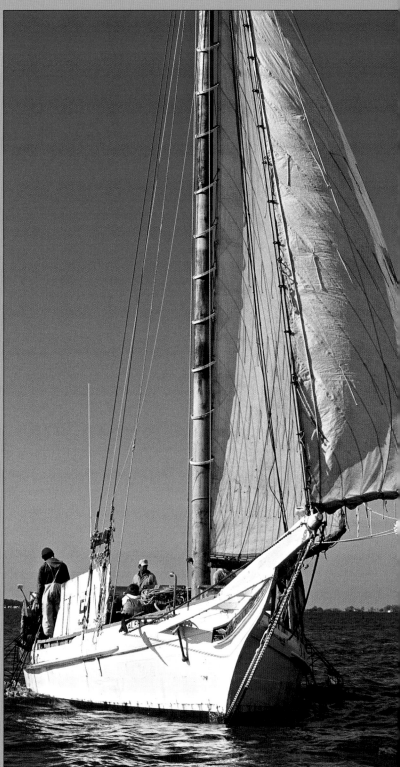

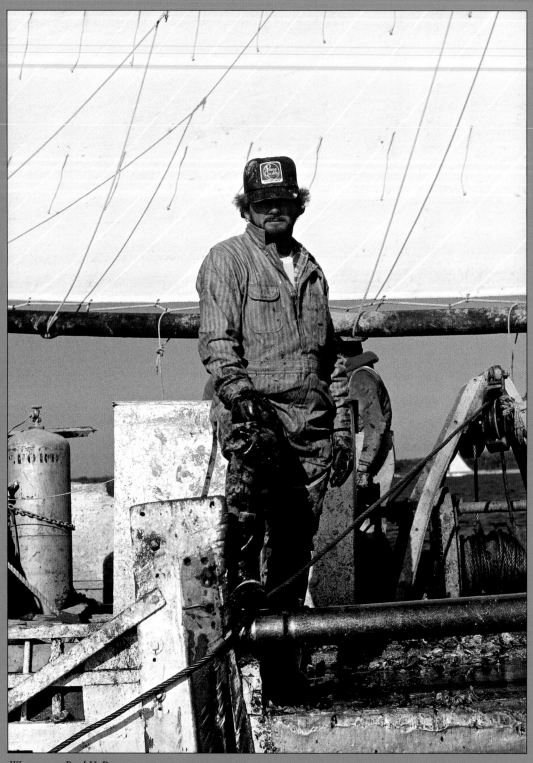

Waterman, Paul X. Benton

The boats were very close together on the oyster bar. It was so
quiet that the captains and their crews could talk to one another
in normal voices as they passed.

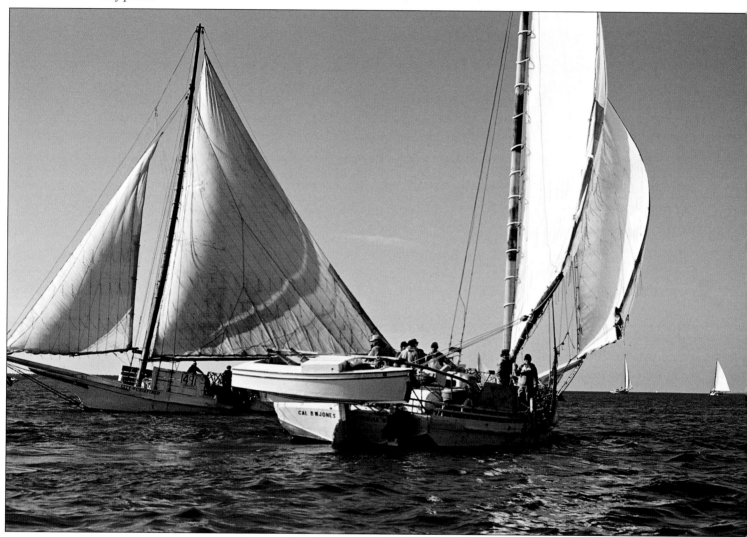

Captain Dicky was at the helm of the *Caleb*, and the crewmen were on each side of the deck. The dredges looked full as they came out of the water. To get most of the mud out of the dredge before it dumped its contents on the deck, the crewmen dipped the dredge back into the water a couple of times, as though dipping a tea bag in and out of a cup of hot water. Then the catch was dumped onto the deck, and the crew sorted through it on hands and knees to separate the good oysters out. They shoveled the empty shells, undersized oysters, rocks, and other debris back into the water.

After my turn with the camera, I took the helm of Mike's boat again. Mike continued snapping pictures for another couple of hours, then we headed back to the boat ramp. On our way, we stopped to photograph a group of shaft tongers who were working in shallower water than the men with the Skipjacks. These men were standing on the washboards of their boats, catching oysters with long, wooden-shaft hand tongs. It looked as though they were using gigantic chopsticks to pick the oysters off the bottom.

"Now that's got to be a hard way to make a living," I said to Mike as we headed to the ramp.

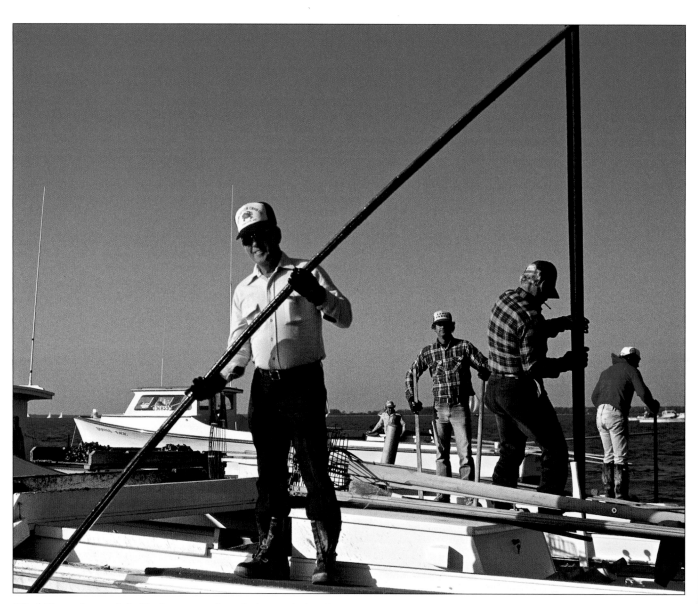

"Shaft Tongers" at work "raking" oysters up from the bottom by hand.

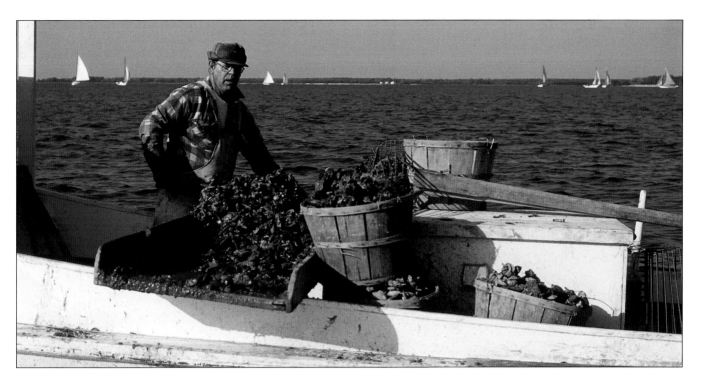

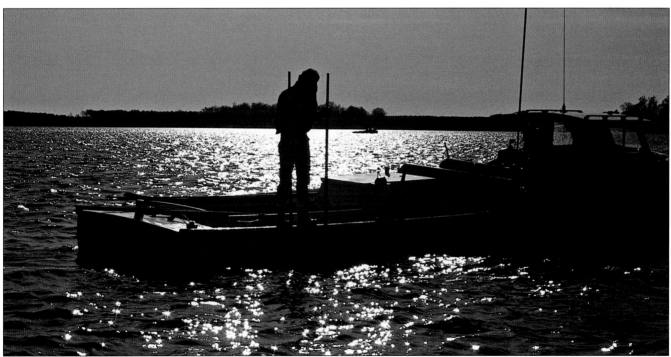

Now, that's got to be a hard way to make a living!

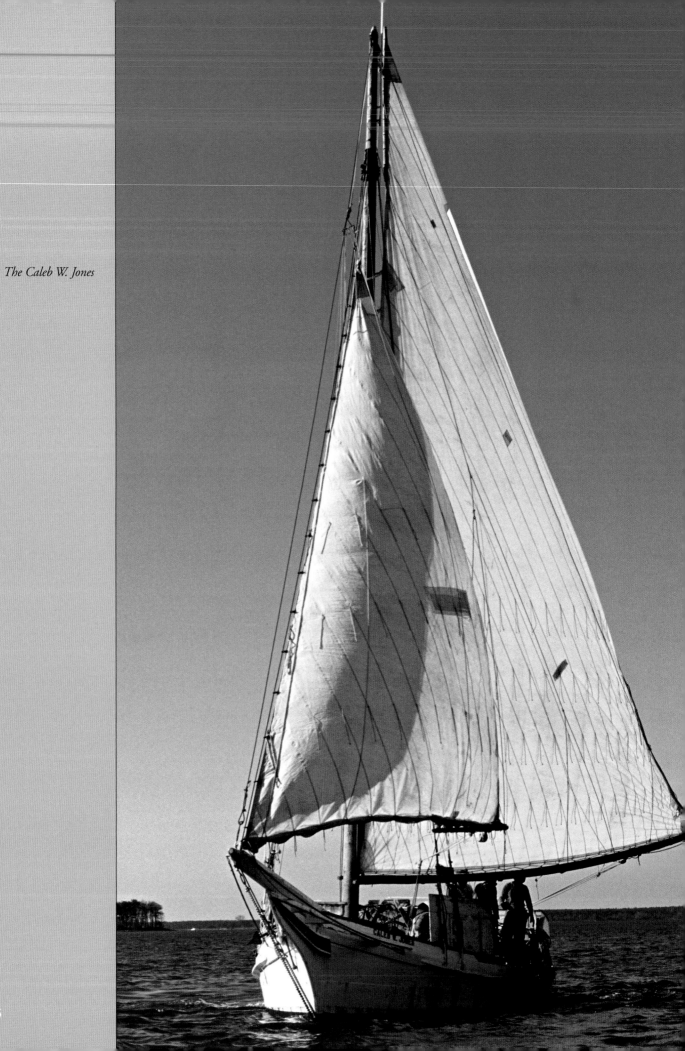

The Caleb W. Jones

Five

The *Caleb W. Jones*
A Wind-Powered Oyster Dredge Boat

Built in 1953 by Hubbard Rice in Reedville, Virginia, the *Caleb W. Jones* is one of the few remaining Skipjacks licensed to dredge oysters in Chesapeake Bay and its tributaries. The *Caleb* is forty-four feet long and sixteen and a half feet wide. Her mast is sixty feet high and she carries a four reef point main sail and jib. A very shallow bottom boat, especially when the centerboard is up, the *Caleb* can navigate in as little as three to four feet of water.

The *Caleb* has two sources of locomotion, the wind and her push or "yawl" boat, as it is commonly called. The yawl boat is also used to power in and out of port for increased speed on calm days and for better maneuverability when docking. The *Caleb's* present yawl boat was built by Roger Hoffman of Wenona in 1969. It is fourteen feet long and five feet wide and is equipped with a powerful engine. The yawl boat is lowered from the *Caleb's* stern into the water through a system of ropes and pulleys. The Maryland Department of Natural Resources limits the use of yawl boats while dredging to Mondays and Tuesdays (power days) in an effort to limit the number of oysters harvested. Only Skipjacks can dredge oysters in the bay and its surrounding rivers; neither dredgers nor tongers can work on Sundays. Captain Dicky says he's happy to go along with this because he knows that if there are no more oysters to catch, his way of life will be lost.

After a long day of dredging oysters, the powerful little boat is lowered into the water and its bow is secured into place against the *Caleb's* stern. Captain Dicky then directs the crewman in the yawl boat which way to position the little boat's stern. Dicky combines the positioning of the yall boat's stern and its throttle and gearshift with the appropriate use of the *Caleb's* rudder to effectively navigate the vessel into port.

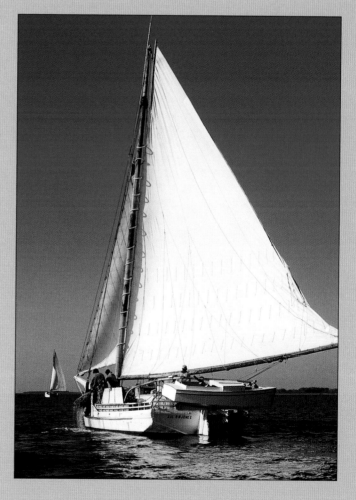

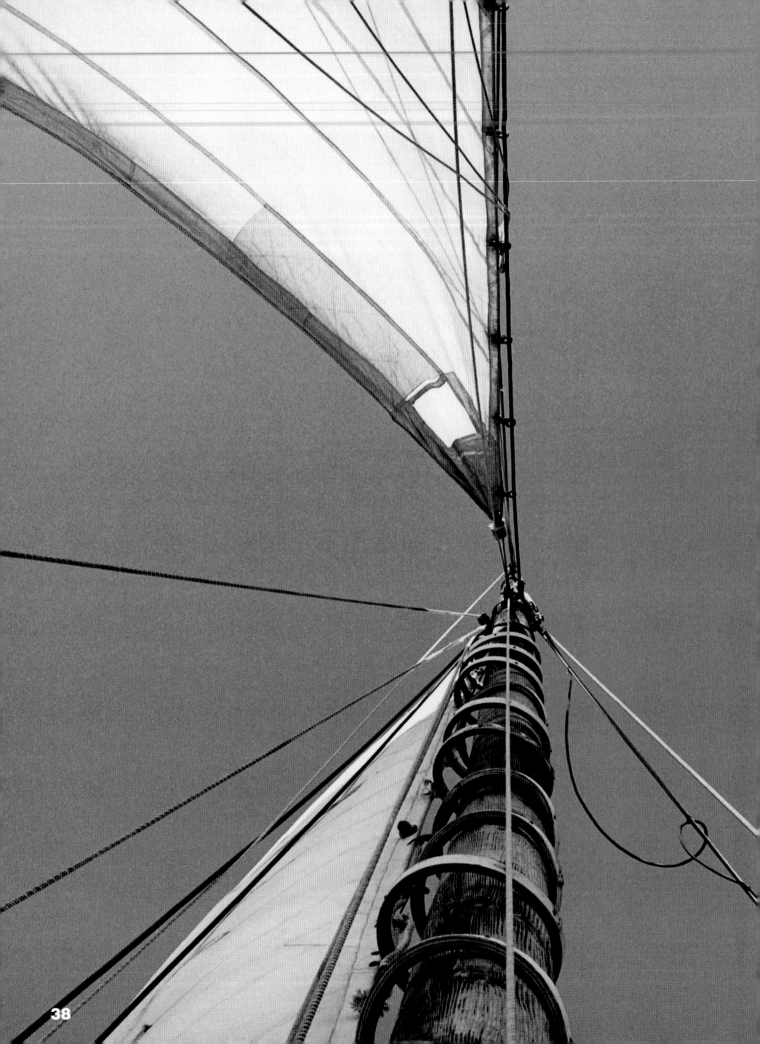

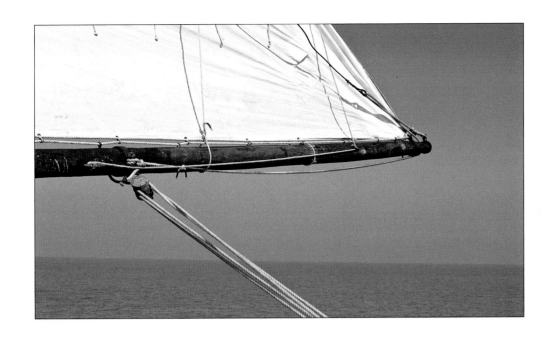

*Mast, sails and rigging "gather"
the wind and propel the Caleb.*

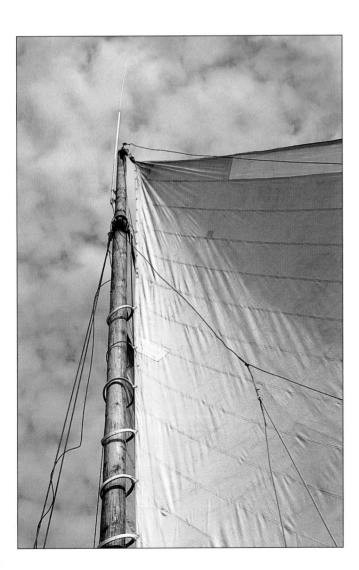

Some of the captain's "tools of the trade" include the compass, yawl boat throttle and gearshift, gloves, rope and turnbuckle, which leads to the centerboard, plastic motor oil container tied to a rope on one end and a weight on the other and used to mark a particularly good spot on the bottom so the same spot can be easily found again.

You can tell where Captain Dicky stands by the worn area on the deck.

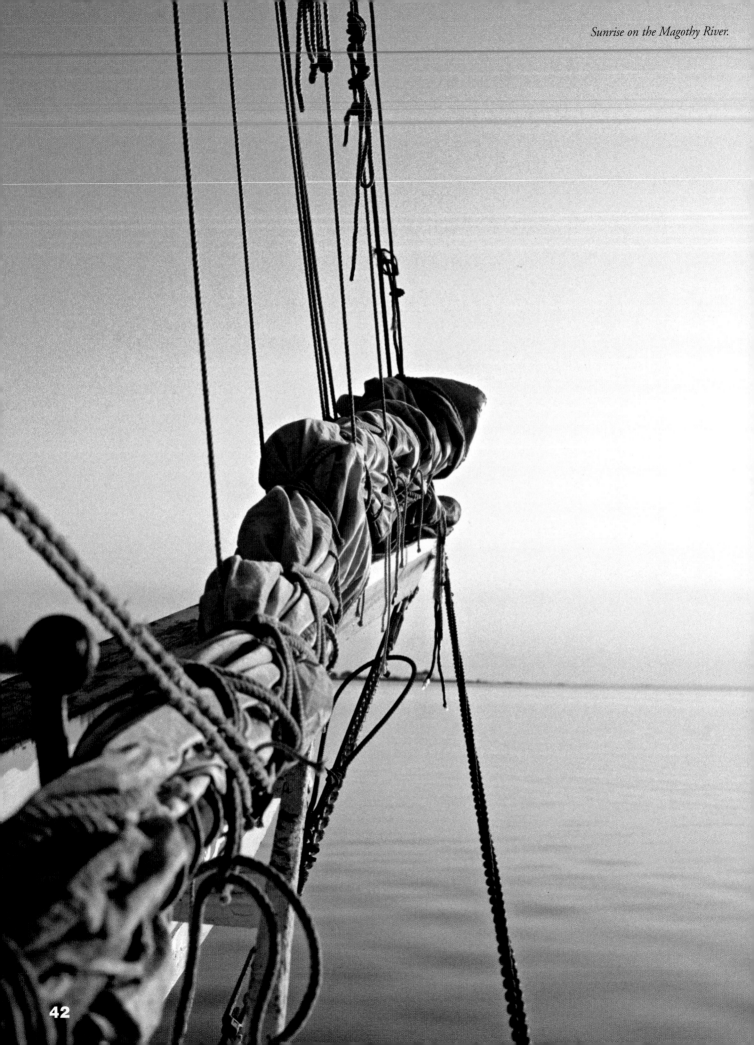

Six

The *Magothy River*

I was invited to sail with Dicky on the Magothy River, so I arranged to meet him on the Western Shore (the mainland located west of Chesapeake Bay) at Captain Clyde's Marina in February, 1984. "It's located on the Magothy River, just off Rt. 2 and it's easy to find," Dicky told me. He gave me specific directions and ended the conversation with, ". . .and if you want a hot breakfast, be there by 5:00 a.m."

When I left my house in Salisbury at 2:30 a.m., it was about 20 degrees and the air was calm. The sky was crystal clear, and a half moon was shining brightly. I arrived before daybreak and walked to the water's edge. Because it was still dark, I couldn't see much of the marina, but I did notice that Captain Clyde's establishment was slightly bigger than the surrounding homes and that he served food. I think he had a bar there, too.

When I hit the docks, I could see a light coming out of a Skipjack's cabin hatch. I got a little closer and, sure enough, it was the *Caleb*. As I approached, I could smell the aroma of good food mixed with the salty sea air. I poked my head into the cabin and was greeted by the friendly face of a tall black man who introduced himself as Buster. Buster was cooking corn fritters.

I could feel the warmth billowing out of the cabin as I was welcomed in. Compared to outside, it felt like 100 degrees in that cabin. Maybe it was. Buster introduced me to a man named Clyde. Not Clyde the marina's owner, Clyde the waterman who worked for Dicky. Buster explained that Dicky wasn't there yet but was expected any time. While we waited, Buster served a hearty breakfast, and we started to get to know each other.

I learned that Buster had worked for Dicky for eight or nine years and became the cook after his first or second year. Buster had a close-cropped beard and mustache that surrounded his broad smile. He was soft-spoken and had an easygoing way about him. I also learned that Clyde had worked for Dicky on and off for a couple of years. Clyde was shorter and stockier than Buster, and had rough skin and a thin mustache. He didn't say much. I think it might have been because a newcomer was aboard. Anyway, he was cool, distant, with an air of being tough.

The men told me that they slept aboard the boat, as did the crew on the *Krentz*, which was moored nearby. They stayed during the week and went home on weekends. They've done it this way for a long time.

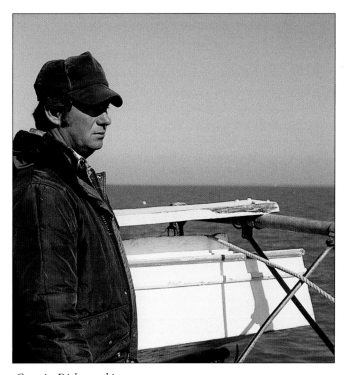

Captain Dicky sets his course.

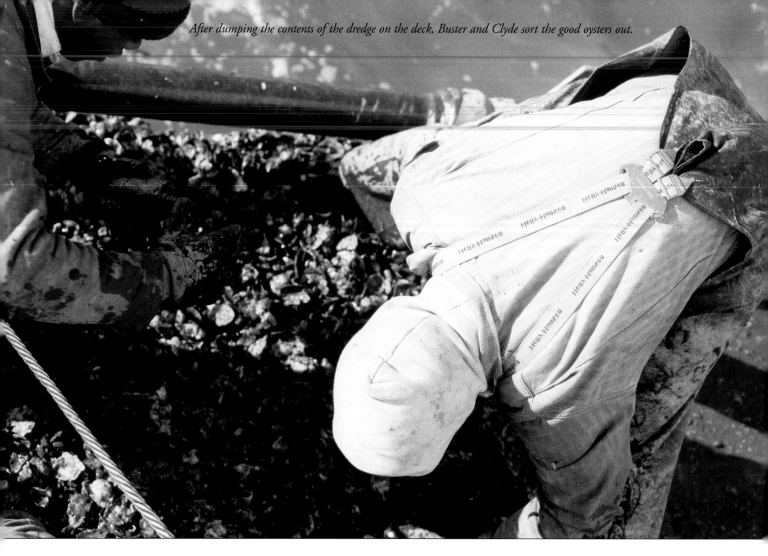

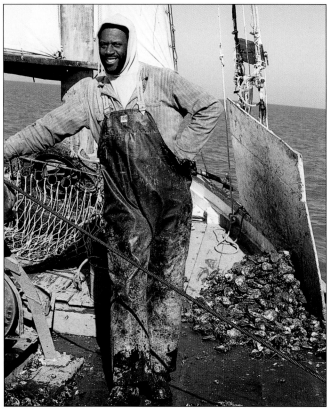
Buster takes a break while the dredge is pulled across the floor of the bay.

"Not many amenities," I thought, "but that rickety looking little stove sure does put out heat."

When Dicky arrived, he quickly ate a fritter and went to work examining the *Caleb* to see if she was ready to sail. "Fresh water on board?" he asked Buster.

"Yep," Buster replied.

By then it was first light, and I could see very few work boats in the marina. They were mostly pleasure sailboats. The only other Skipjack was the *H. M. Krentz*, captained by Dicky's brother, Ted.

I noticed a small flock of white ducks paddling around as we lowered the yawl boat, cast off, and powered our way toward the mouth of the Magothy River and the Chesapeake Bay. We passed several nice homes before the little river began to open up. Just as we reached the mouth, the sun began its daily trek across the sky. Mother Nature was treating us to a glorious sunrise in various shades of pastels, both all along the horizon and mirrored in the perfectly placid water. "Slick cam," as Dicky would say.

I walked up to the bow of the *Caleb* and took in the view. When I turned around, I could see that a little behind us and off to the right were Ted and the *Krentz*. The half moon, still in the sky, was just above them. Their reflection was rippled from the wake of the *Caleb* and her push boat.

"Why are you dredging on this side of the bay?" I asked Dicky.

"The oysters are a little bigger over here this year, and if the bay freezes, it's gonna freeze on the Eastern Shore first. That's 'cause of the westerly winds. Don't want to get iced in over there."

There was a light breeze blowing by the time we reached our destination. Ted and the *Krentz* were out of sight by then. Dicky told me they were dredging a little to the north. When Clyde and Buster dropped the dredges for the first time, it had warmed up to a scorching 32 degrees.

It was a very slow day. The catch was light. The only oysters they kept were large, but there just weren't many of them. The crewmen ended up shoveling back into the water most of what had come up in the dredges. To make matters worse, the wind was intermittently too light to pull both dredges at once. At those times, Dicky had to settle for one dredge.

The water had a brownish tint to it, not the pretty blue-green I had seen on the Choptank River the previous year.

Dicky patiently responded to my many questions with relaxed and well-informed answers. I did try my hand at culling the oysters to help keep warm. Not for long though—it was back breaking work!

On our way back to Captain Clyde's, Dicky suggested I return at the beginning of next season when he was dredging on the Choptank River.

As we approached the mouth of the river, I could see Ted's boat, the *Krentz*, tied up alongside what Dicky called a buyboat. They were unloading the *Krentz*'s catch. We waited our turn to do the same, then made our way back to the marina.

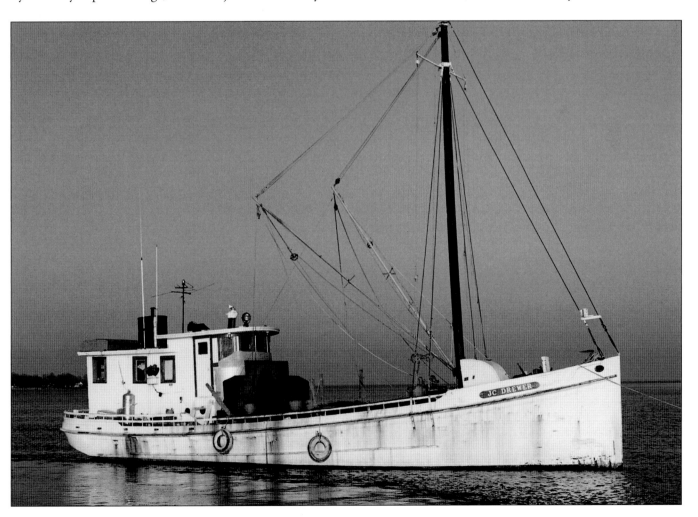

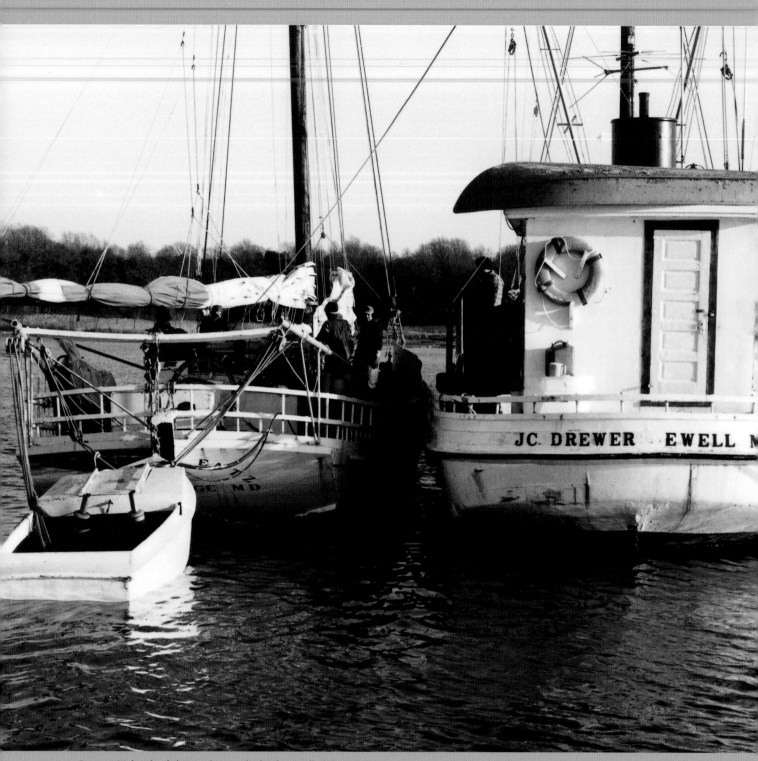

Captain Ted unloads his catch onto the buyboat called the J.C. Dewer.

Seven

Wenona Harbor

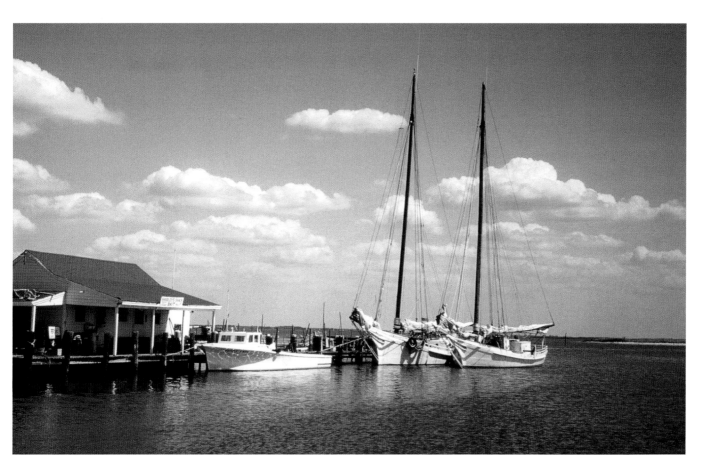

For six months I waited. It was September 1984 and the new oyster season hadn't opened yet, but I could wait no longer. I jumped into my truck and headed south to Deal Island and Wenona Harbor.

I knew I had reached my destination when my eyes fixed on the two tall masted Skipjacks moored on the far side of the harbor. Even from a distance, it was clear that the men who owned the *Caleb* and the *Krentz* had spent an enormous amount of time and energy on their boats. They looked clean as a whistle with their fresh coats of white top paint, and they were loaded with the equipment used to catch oysters. A few colorful flags hung from the *Krentz's*

rigging. "These boats are almost always together," I thought, "and they look good together." Their beauty was enhanced by their nautical surroundings and the fluffy white clouds set against the blue sky. There was a sandy beach on the far side of the harbor bordering a small, uninhabited island called Little Deal.

The harbor was very quiet. I think most of the resident watermen were either running fishing parties, finishing up their crabbing seasons, or planning their seasonal transition to oystering. Today it didn't matter.

I just sat there for a long time. A feeling of serenity overwhelmed me and I took a deep breath.

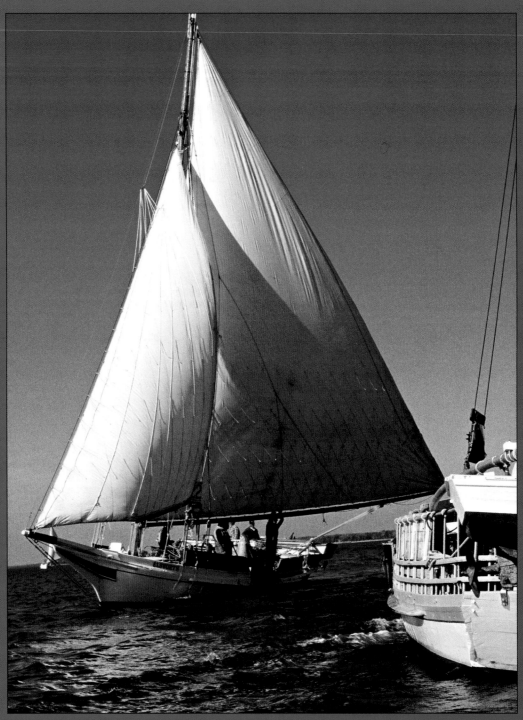

The Elsworth

Eight

Rebuilding the Caleb

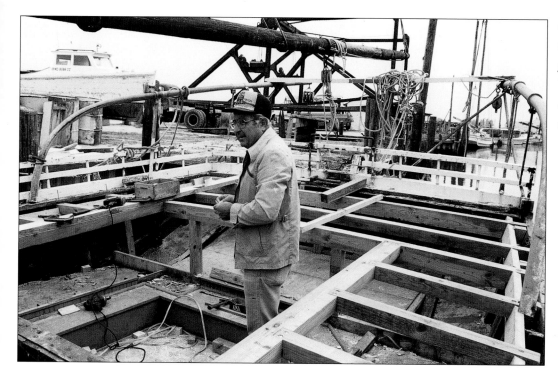

Soft-spoken and of medium build and graying hair, Junior Willing is the main architect of the Caleb's rebuilding project.

Day 1

My alarm sounded at 4:45 a.m. By six o'clock, I was at Windsor's Marina, where I met Don Fountain for an early morning fishing trip. Don is always good for some laughs no matter where he is or what he's doing. Makes for a good fishing buddy.

We fished until 9:00 a.m. and caught two trout each and Fountain caught a bluefish. We arrived back at the marina about the same time as Captain Harry Windsor. Alone, he had caught 20 trout. I wondered about how well this seasoned waterman knew the bay and its inhabitants.

Fountain went on to work and I went to work cleaning my boat, the *Cash Flow*, a 21-foot Grady White with a walk-around and a small cabin. Around 11:00 a.m., I went to find Captain Dicky and the *Caleb*, to learn about, watch,

and photograph the rebuilding of her deck and cabin in preparation of the 1984-85 oyster season.

After lunch, I headed to Scott's Cove Marina, just across the gut from Windsor's. As I drove around the marina for the first time, I noticed work boats of all sizes and shapes. I found Dicky and the *Caleb* on the southern side of the marina next to the boat lift.

After exchanging greetings, Dicky introduced me to Junior Willing. Soft-spoken and of medium build, with graying hair, Junior was the main architect of the *Caleb's* rebuilding project. Dicky told me about Junior's skill and knowledge of boats and that he was one of a very small number of traditional boat builders still working in the bay area. After a while, I began to understand that his craft is endangered as much as the Skipjacks themselves.

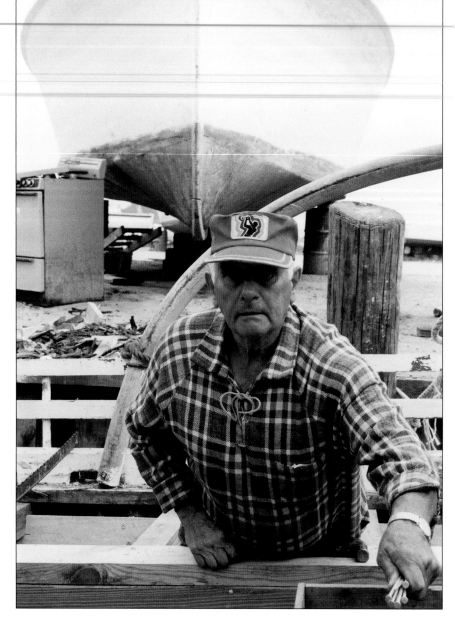

Also on the job was Junior's "helper," Chester. A plump, jovial man with solid white hair, Chester is a retired paper mill worker from Pennsylvania. "I worked that job for thirty years," he said. "Just as my pension was about to begin, the company folded and left me in the cold." At some point, I overheard someone say of Chester, "I hope I'm as tough as him when I'm his age. He's 73 years old."

Junior and Chester had spent most of the morning removing the bad wood from the *Caleb*. She was torn down from her stern to just in front of the cabin. Several main floor beams, the decking, and the cabin were already missing. She looked unusually large in this condition, just the hull exposed. Most of the old wood was piled high on the bank next to the boat, with the remaining pieces scattered over the stern. Dicky informed me, "The cabin will be a couple of feet taller when she's done."

I tried to make myself useful by picking up debris while Junior and Chester went about the business of rebuilding the *Caleb*. Both men were quiet at first, but it wasn't long before they made me feel right at home.

After a while, a man named Morris Marsh stopped by to say hello. Morris is a waterman from Smith Island who was in the marina for some maintenance on his boat. He too was preparing for the new oyster season. Morris was the first of many people to stop by to say hello and chat during the project, and some even lent a hand. In fact, Morris jumped right in to help us take the main sail off the *Caleb* and load it into the back of Dicky's pickup truck. The marina was bustling with activity as boats came and went.

Dicky and I left Junior and Chester to their work and went to Wenona to check on the yawl boat. A guy named Roger Hoffman was to begin on her overhaul the following

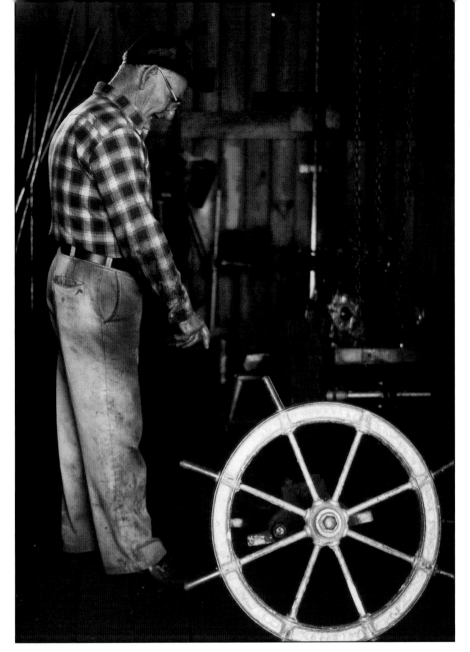

Alfred May examines the steering wheel and gears in his shop located in Princess Anne.

week. After that, it was a good two-hour drive to St. Michaels and Chesapeake Canvas to have the three small tears in the sail mended. On our way, we stopped in Princess Anne to drop off the steering wheel and gears to a machinist named Alfred May. A rung had broken off and was lost and a new one had to be made and welded on. Alfred was an elderly gentleman with a shop behind the Dollar General store. The captain's hat he wore suggested that he, too, had been a waterman in his younger days. We went inside and, to my surprise, the machinery looked as old as Alfred. When we left Princess Anne, Dicky assured me that Alfred and his antiquated-looking machinery would do just fine.

After we dropped the canvas off in St. Michaels, Dicky decided to go past Easton to see the new Skipjack called the *Talbot Lady*, moored at Wye Mills Landing. The boat was very clean—almost too clean to work with. Dicky said the man who built her had some problems to iron out yet.

On the way back to Deal Island, we stopped at the Cambridge boatyard to say hello to Captain Darryl Larrimore from Tilghman Island. He was at the railway rebuilding his Skipjack, the *Nellie Byrd*, one of several Skipjacks that Dicky's father had owned years earlier.

We went on to Linkwood, where we picked up the dredges that had been reworked by a man named Joe Brocato. Scraping oysters up from the bottom of the bay can be hard on a dredge.

Our last stops were back in Scott's Cove, where we dropped off some 4" x 4" posts that had been donated to the cause by someone Dicky knew. Finally in Wenona, we dropped off the newly refurbished dredges.

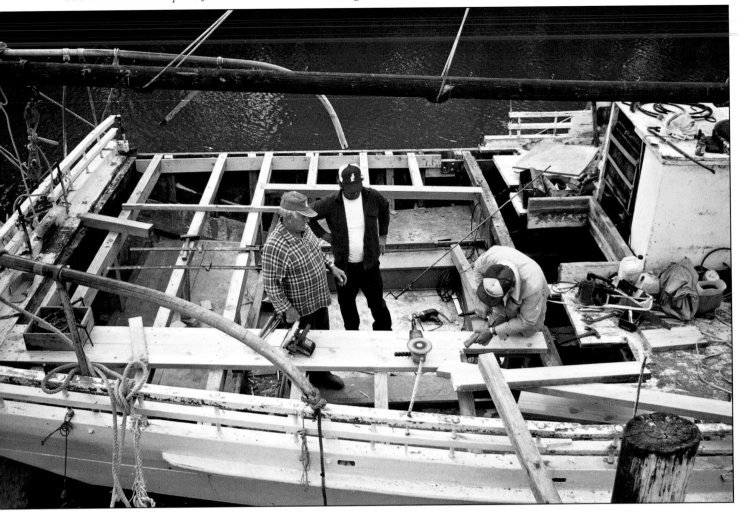

Day 2

On my second visit to the renovation site, I began to appreciate the skill of these craftsmen. Junior and Chester had finished the beams and started replacing the deck. Rebuilding the *Caleb* had begun in earnest. Serious about his work, Junior proceeded in a slow but steady pace. Many people came over to talk to him during the day. They usually wanted his advice on something about their boats. Other times they were just looking to say hello, or they needed a part. While he talked, his work continued.

On several occasions, his position as harbor master interrupted his work on the *Caleb*. He put boats on the railway, or dry-dock. The other watermen in the community were preparing for the new season, too.

Junior told me he had worked on the water for thirty years. "I think it must be in my blood," he said. He also told me he had been captain of the Skipjack the *Amy Mister*. "She's in her final resting place in Whitehaven now," he said. After a slight pause, he continued, "I think she was built in 1917 or 1918."

I remembered that I had some photographs of that boat on file and made a mental note to bring one for Junior.

Both Junior and Chester were kind to me even though I was a stranger. They patiently answered my many questions. Over the next two or three weeks, I began to admire these craftsmen who struggled to maintain their nautical way of life.

Just as I was ready to leave for a five o'clock haircut, Fountain showed up. He tried to talk me into going fishing. I told him, "Sunday morning would be good. Let's ask Nussie (pronounced—Nu-sē) if he wants to go."

Junior positions a boat that is about to be lifted out of the water.

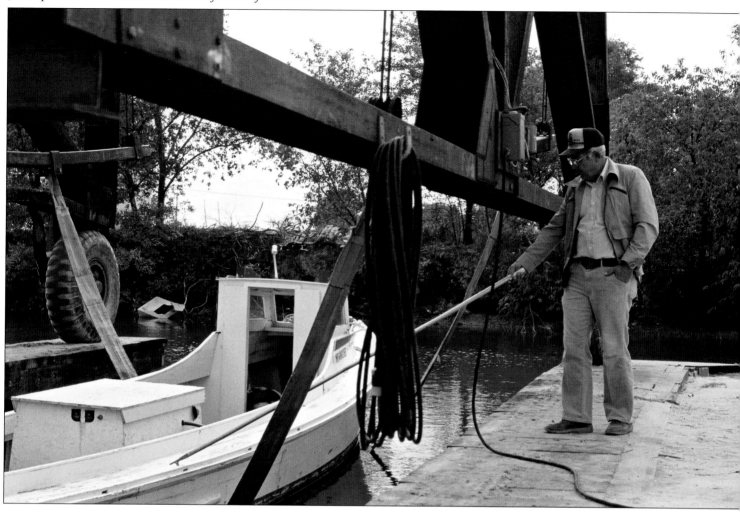

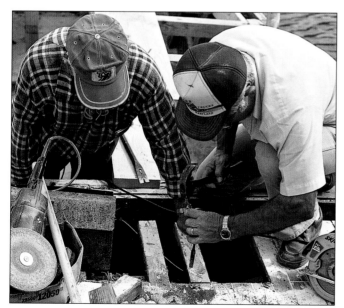

Connecting the new deckboards to the old ones takes a little extra time.

Day 5

On Sunday I met Fountain in the afternoon for a couple hours of fishing. I asked him to stop by the *Caleb* first so I could drop off a picture of the *Amy Mister*. For Junior's sake, I wished I had taken the picture when the boat was in better shape. When we got there, Junior and Chester were building a new centerboard about five feet wide, twelve feet long, a couple of inches thick and very heavy. It would be installed in a prepared opening in the center of the *Caleb*. The centerboard is used to help stabilize the Skipjacks while sailing and dredging in moderate to strong winds. I gave Junior the photograph. From the look in his eyes, I realized he hated to see the boat, which meant so much to him, in such poor shape.

Crabs

During the summer of 1984, I was in Wenona Harbor looking for Captain Dicky Webster. Realizing that Dicky had taken a fishing party out on the *Standor III* and had not yet returned, I headed for my truck. Just then, a man I'd met two weeks earlier on a fishing trip with Dicky rode up on his moped. His name was Bernie. We called him Captain Bernie since he, too, had worked on the water all his life.

We began to talk. I told him about my work with Dicky and the *Caleb* and expressed my desire to photograph some crabbers. Bernie told me to go see "Nussie," across Deal Island Bridge and to the right (coming from Wenona). "Just tell 'em you're a friend of Don Fountain," he said.

I did just what Bernie suggested, and from the very first minute I met Robert "Nussie" Webster and his grandfather, Captain Harry Windsor, they have been very good to me, providing me with a dynamic photographic story about peeler potters. Over the years, these men have become much more than subjects to photograph. Today I am proud to call them friends!

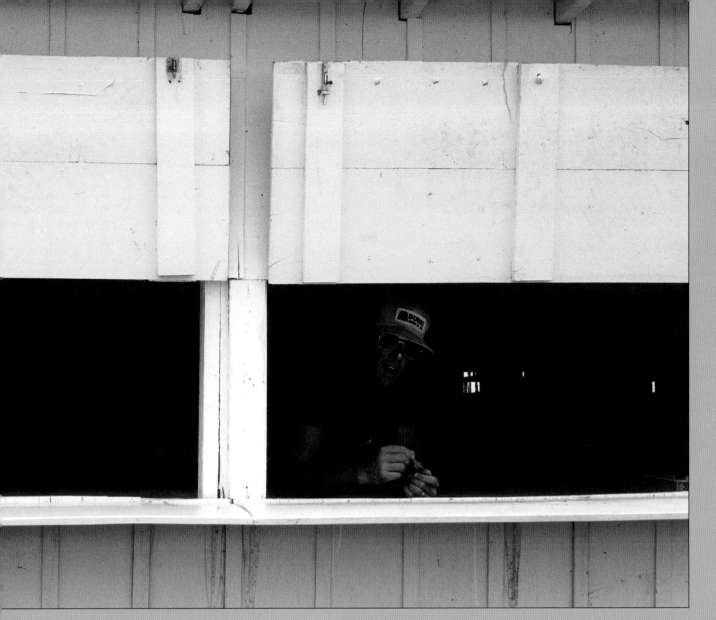

Robert "Nussie" Webster

This quickly became one of my favorite places to visit, where time became unimportant.

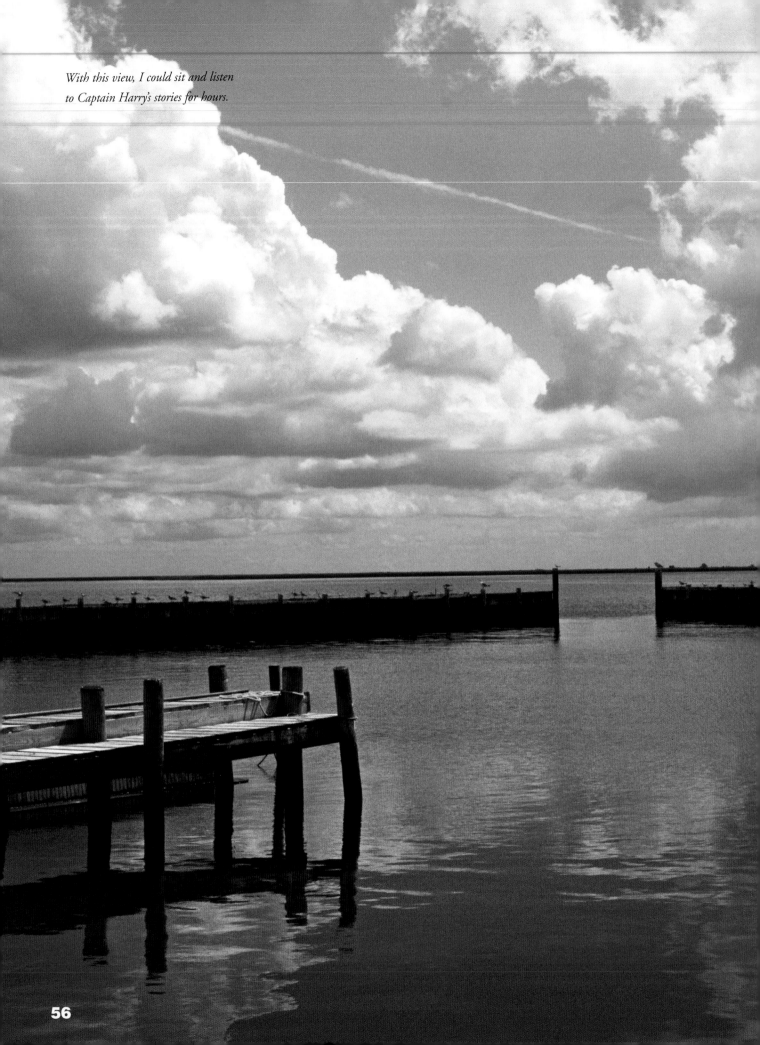

With this view, I could sit and listen to Captain Harry's stories for hours.

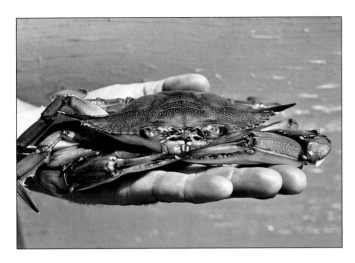

*This "whale" of a soft crab
is bigger than a man's hand.*

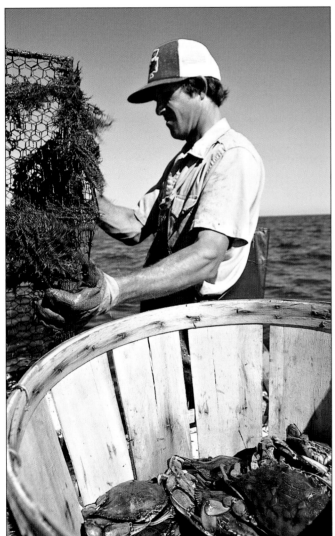

*It's late in the summer season and Nussie is catchin'
more hard crabs than "peelers."*

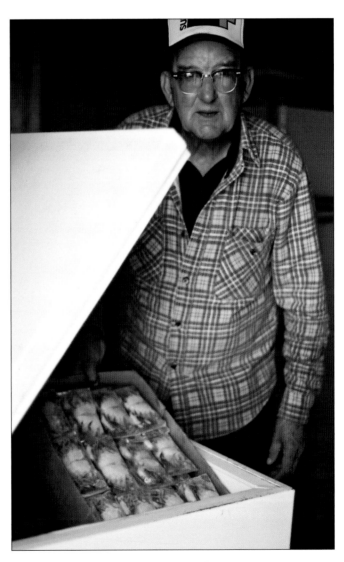

Captain Harry shows me some frozen soft crabs.

We left and headed to Windsor's Marina and my boat, the *Cash Flow*. Flood tide was higher than I'd ever seen there. The dock seemed as if it were floating. Fountain carried his usual amount of fishing gear: two coolers, tackle box, two or three fishing rods, and a bag for clothes and food. "This man is a fishing maniac," I thought as we walked through the water over the dock on the way to the boat.

Our first catch was a huge oyster toad, an ugly fish. Sometimes called a brown trout, an oyster toad is brown and real slippery. It has a huge mouth and vise-like jaws that can crush an oyster shell. But it wasn't long before we had a few four- to five-pound trout on board and they were beautiful. The vivid colors of the sunset on the western skyline and their reflections on the water made the evening that much more enjoyable. We fished until just after dark, and headed back.

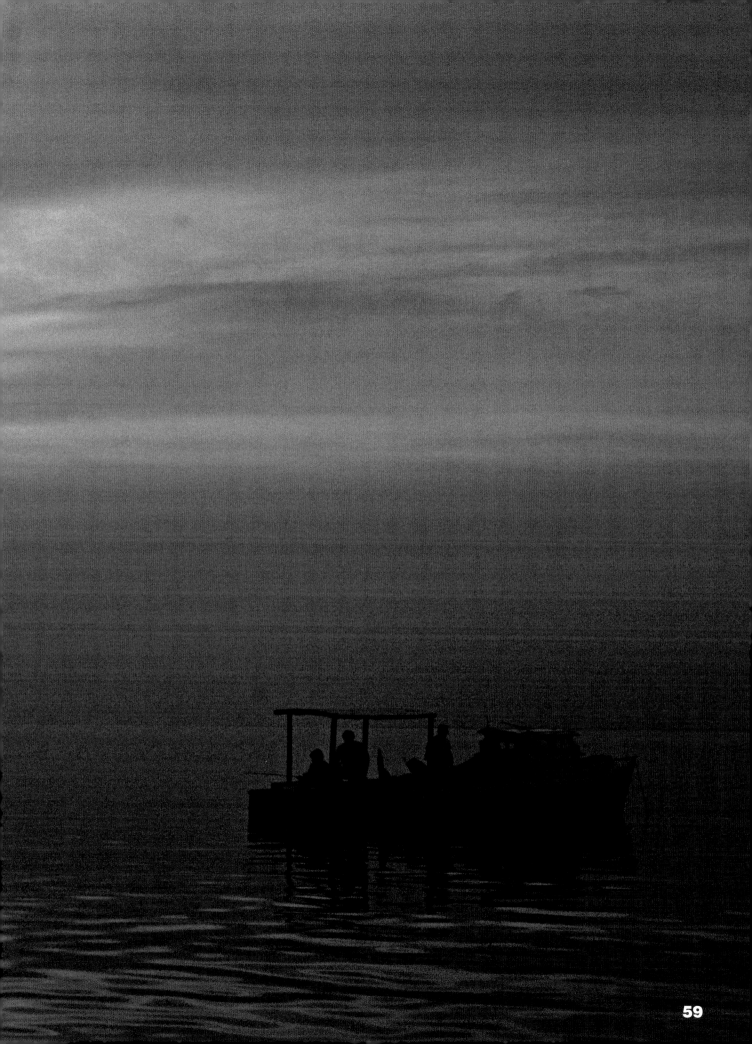

Day 7

Dicky had previously given me the *Caleb's* portholes to have dipped and cleaned to remove the old crud and refinished with new glass. I started the day by knocking the broken glass out of each porthole in preparation for this work, then drove to Laurel, Delaware, to drop them off at a place called Procino's Plating.

When I arrived at Scott's Cove late in the morning, Junior and Chester had completed the floor beams and decking. Dicky explained that the men had gone to lunch, and asked me if I wanted to go to Wenona to check on the yawl boat. (Some of the locals draw out the pronunciation to "Wee-*no*-nah".) We found the little yawl boat bottom up, near Dicky's brother's Skipjack, the *H.M. Krentz*.

A friend of Dicky's by the name of Roger Hoffman was there, working on the push boat. He's the guy who originally built her. "I'm retired mostly," Roger said. "Dicky talked me into this!" He went on to say, "I built it in '69, the same year Dicky's father, Captain Clifton, bought the *Caleb*."

Roger had made and installed a new bow piece where she butts up against the *Caleb's* stern, and was running cooling pipes from the motor area to the stern. When this was done, I helped Dicky paint a coat of primer on her bottom.

A little later, Dicky took me back to Scott's Cove in Chance to get my truck. No one was there, but it was obvious someone had been. The construction on the cabin was proceeding quickly . . . so fast in fact that I thought, I better get the new glass for the portholes tomorrow and get them back here soon. These guys are taking off with this project.

Day 9

After a breakfast of pan-fried rockfish and potatoes, I took off for Laurel and Procino's to pick up the portholes. Mr. Procino spoke fondly of his fishing trips with Captain Clifton nine or ten years earlier. He mentioned that they rarely came home empty-handed. Then our conversation turned back to business. "One of the snap rings broke while we were removing it," he said, as he handed me the portholes. "Oh, well," he said. "It'll still work."

I then went to buy two round pieces of glass for the portholes. The glass felt a little loose in the portholes so I went to see Jim Coffman at work. He edged one piece with silicon and put in the snap ring. Jim then took the other ring, which was broken, next door to Jack Jones' place to see if it could be brazed.

We left it there and I went to look for brass cotter pins and wing nuts. Dicky had said they wouldn't rust. I looked in four places with no luck.

Jack couldn't braze the broken snap ring, so Jim decided to silicon both pieces in place. It worked. Before I left, Jim's buddy, Jack, gave me some stainless steel cotter pins. "They won't rust," he said.

I wasn't back at Scott's Cove very long when Dicky asked me about my boat trailer. "Is it still over at Windsor's? Can we use it to move the yawl boat?" What an improviser. I didn't hesitate: "Yes, of course."

We picked up the trailer and went to Wenona. It didn't take long for Dicky to find some men to help us roll the heavy little boat onto my boat trailer. It didn't fit very well and it wasn't pretty, but it worked. Back at Scott's Cove, we unloaded our cargo near the *Caleb* and I picked up my camera.

A little later, the construction on the cabin was proceeding quickly.

Roger had made and installed a new bow piece and was running cooling pipes from the motor to the stern.

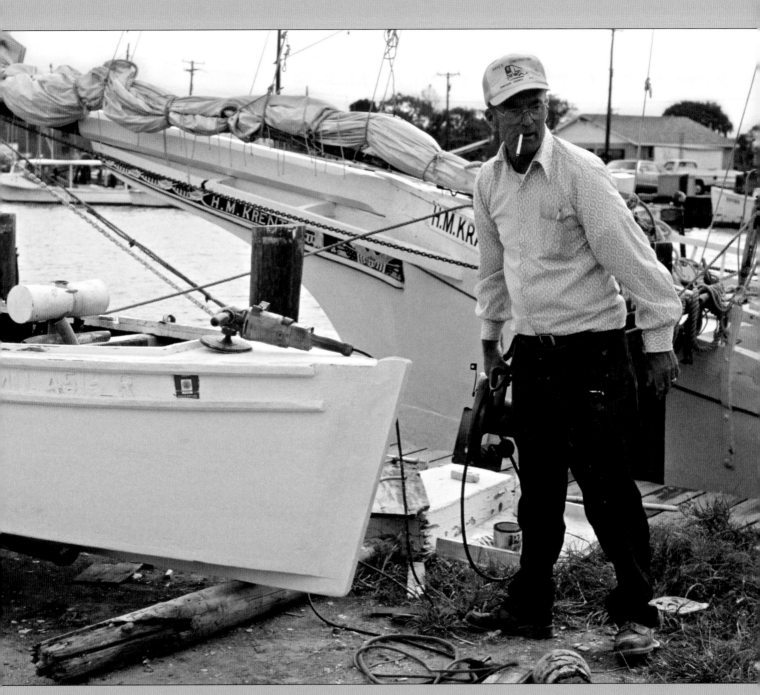

Roger Hoffman: "I'm retired mostly. Dicky talked me into this."

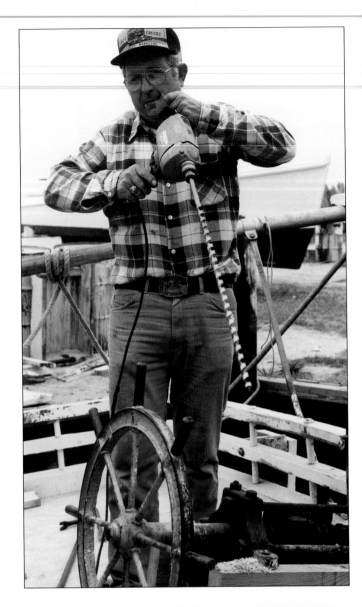

A man Dicky called Tutor (Edward Tarlton) was there fiddling with the portholes I had dropped off earlier. The threads on the stems were worn out and had to be replaced. He told Dicky, who immediately went to get some old portholes so Tutor could take some parts off them. Tutor, a retired waterman who often lent a knowledgeable hand, took the parts he needed from the old portholes. It worked and they were good to go.

Meanwhile, Junior and Chester were hard at it, attaching the newly repaired steering wheel and gears. The exterior of the cabin was nearing completion. When they finally took a break, Dicky and Junior talked about the work to be done on the rudder.

I took my trailer back to Windsor's, where I found Captain Harry in his favorite spot—the shanty overlooking the marina. I went in and sat and just listened for a long while. This was quickly becoming one of my favorite places to visit, a place where time became unimportant. Captain Harry had made me feel welcome from the first day I met him. I could listen to his stories for hours. The smell of salt air, the seagulls soaring overhead and the view overlooking the harbor added to the tranquil atmosphere.

When five o'clock came around, it was time for Captain Harry's dinner. Mrs. Windsor always had it ready at five o'clock sharp.

With the exterior of the cabin and railing nearing completion, the men attach the davit and install the newly repaired steering wheel and portholes.

Day 12

I arrived at Scott's Cove around 4:30 in the afternoon to find Buster working. "A real reliable guy," Dicky described Buster. "That's important, especially since he's the cook, too." Jack Willing was busy cutting the opening in the cabin for the portholes. Jack is Junior's brother, partner, and co-owner of Scotts Cove Marina.

I saw that Stan Daniels' Skipjack, the *Howard*, had arrived. Dicky noticed I was looking at her and said, "She's here for some minor repairs. Stan's gettin' ready for the new season and the races at Sandy Point, too."

A little later, Jim and Don arrived and reconnected the CBs, compass, and depth finder they had removed from Dicky's fishing party boat, the *Standor III*. Fishing season was over and these instruments were needed on the *Caleb*.

The Thomas Clyde

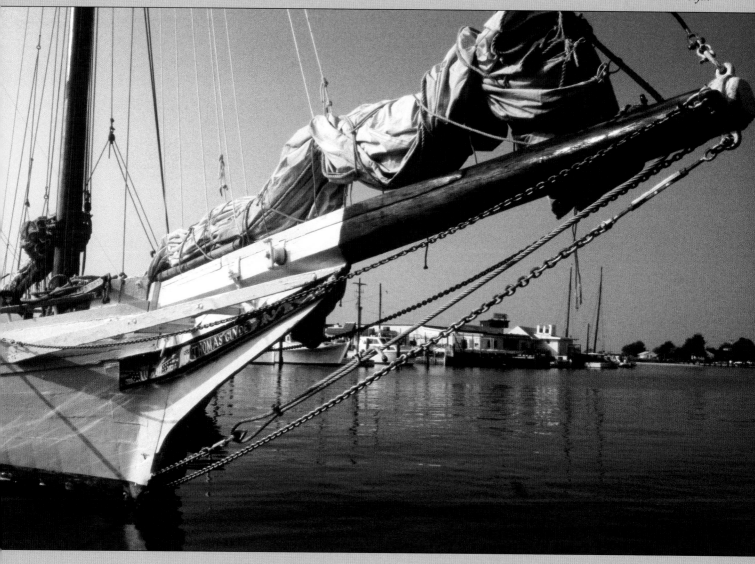

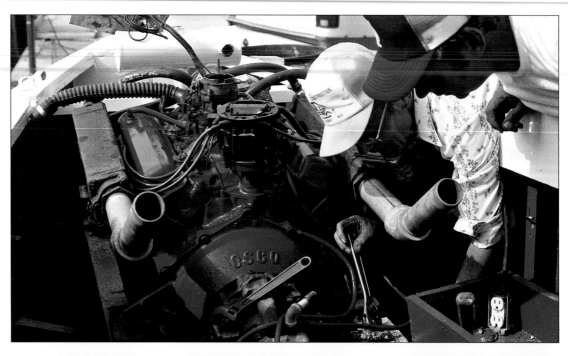

Roger installs the motor in the yawl boat as Dicky looks on.

Even Dicky's dog Bo gets into the act.

As it started to get dark, Stan Daniels came by and told Jack, "The light you lent me doesn't work."

"It worked when I lent it to you," replied Jack.

Stan casually replied, "Oh, yeah. It worked until I dropped it." Everybody smiled.

It was 9:00 p.m. before Jack called it quits for the evening. The inside of the cabin looked good. "We might make it to the races in time," I thought and my heart beat a little faster in anticipation of sailing up the bay.

Day 13

I arrived around 11:00 a.m. and found men working everywhere. Time before the race was getting short and there was plenty left to do. Dicky had everybody working. Buster was painting. A guy named Bruce was there. "I hired him because he owed me money and what better way to make sure you get paid back," said Dicky.

Dicky even had his son, Randy, painting. This was unusual because it was my understanding that Randy did not intend to become a waterman.

Jack Willing

It looked like a herd of beavers had been cutting timber for weeks.

Jack was in the cabin continuing his work on the cabinets. I went inside. It looked like a herd of beavers had been cutting timber for weeks. Wood shavings were everywhere. Jack barely paused as I sat down and watched. As his power planer was screaming while he trimmed the edge of a cabinet door, I tried to imagine a time when this work was all done by hand. No power planers or circular saws. No cordless drills or electric sanders. Everything done by hand. Rough work.

"I hear you're good at building engines," I said to Jack. Someone had mentioned previously that Jack is a very good marine mechanic. I had to ask, "Are you as fast at building engines as you are with this carpentry?"

"Much faster," he replied with a chuckle. His grin portrayed his confidence.

That afternoon, Dicky and I went to Princess Ann to get another piece of glass for the cabin windows. On the way back to Deal Island, I had the opportunity to ask Dicky how long he had been Captain of the *Caleb*. He explained, "I became the captain in 1969—I was twenty-eight years old, the youngest captain on the bay." Then after a slight pause, ". . .at the time." Another pause. "I was in the hospital with a bleeding ulcer by 1970." He said, "You really have to love it." He told me that a Skipjack captain needs to know a little about almost everything—carpentry, electronics, sailing, the weather, the tide, mechanics, and how to deal with people. After watching him rebuild the *Caleb*, I understood why.

Junior and Chester set the portholes and installed the cabin doors and steering box, then grabbed a couple of guys to help put the newly refurbished rudder back on. It was extremely heavy and very awkward. I proceeded to lend a hand where I could and take some pictures between jobs.

Even Roger Hoffman was there finishing up the yawl boat. "Why am I doin' somethin' like this again?" he mumbled to no one in particular. I think he said something about being 70 years old. He lined up the motor with the drive train and bolted her in. Backbreaking hard work.

Dicky installed the propeller on the push boat, with his four-legged friend Bo, a chocolate lab, looking on.

A few finishing touches on the mechanicals and the yall boat was nearly finished. The job was complete when Bruce attached a portion of a tire on the bow for a buffer against the *Caleb's* stern. The buffer had failed in rough weather the year before, and the yall boat was damaged.

Buster paints the new centerboard and rudder.

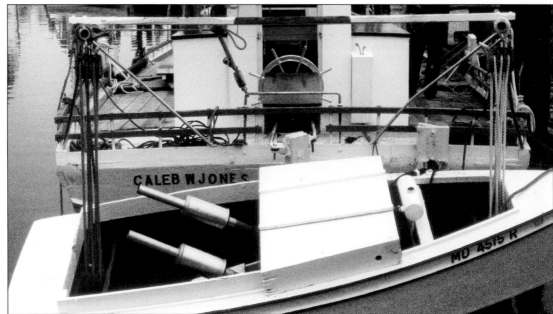

We finally got a replacement for the missing "e" in Cal b W. Jones.

When we returned from Princess Anne, I volunteered to paint the letters on the yawl boat. Fountain and Jim arrived and quickly went to work. Fountain helped Dicky and his son prime the cabin and deck while "Seaside Electronics," Jim's nickname during the rebuilding project, went to work on the communications and navigational equipment. I finished what I was doing and asked Dicky, "What's next?"

"You can paint her name on both sides of the bow," he replied. So I painted Caleb W. Jones on both sides at the front of the boat. As I formed the letters with my paintbrush, I wondered about the man, Caleb W. Jones.

Day 14

It was Wednesday afternoon when I returned to the rebuild site. Jim was already there. He had taken half a day off from work and was planning to use Thursday and Friday as vacation days. During the last part of the rebuilding process, Fountain, Jim, and I got more involved. We were closer to sailing up the bay, and looked forward to the trip with great anticipation. The race was Saturday. We wanted to leave Thursday, but bad weather was expected. Instead, we planned to leave Friday.

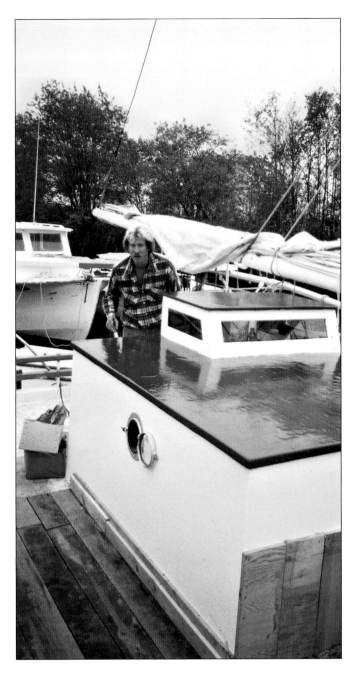

"There's plenty left to do," Jim said, "and time is gittin' short." This was an odds-and-ends day with a lot of painting to do. It took Dicky and I about ten minutes to ride down the meandering road to Wenona to pick up hoses for the push boat's engine cooling system and the antenna off Dicky's fishing boat, The *Standor III*. We returned to finish the decking. Rough planks were nailed on top of the deck to help protect it from the abuse of heavy dredges and rough oysters. The Caleb seemed to have two decks. Dicky explained that they remove the protective planks at the end of each year and replace them the following season.

We all worked until just after dark.

As we were getting ready to go, Stan Daniels drove up in a hurry. He wanted some rope to pull a guy out of the water who had just jumped off the Deal Island bridge. It didn't seem particularly unusual to anybody.

Dicky's youngest boy, Richie, drove up, got out of the car and handed me a check to pay for the trailboards. Trailboards are the intricately designed nameplates that go on each side of the *Caleb's* bowsprit. Fountain had arranged for me to pick them up the next day. Richie nonchalantly mentioned he had to wait before he went back home because an ambulance was blocking the bridge.

The whole incident seemed surreal to me, but, to the residents of Deal Island, it was just another day.

Day 15

I picked up the trailboards on the way to Scott's Cove and arrived around noon.

Fountain, Jim, Randy (Dicky's other son), and I all grabbed brushes and started painting. Dicky and Bruce got the centerboard in and then attached some metal plates to the sides of the *Caleb* where the dredges are pulled up. The steel teeth on the dredges would do serious damage to the *Caleb* without the plates. Then I cleaned up some more. I was always trying to clean and straighten up, since I didn't usually have a specific task assigned.

Jim finished the electrical work and Bruce installed the trailboards. Fountain painted the top of the cabin. We finally got a replacement for the missing "e" in Cal b W. Jones, and installed it on the stern.

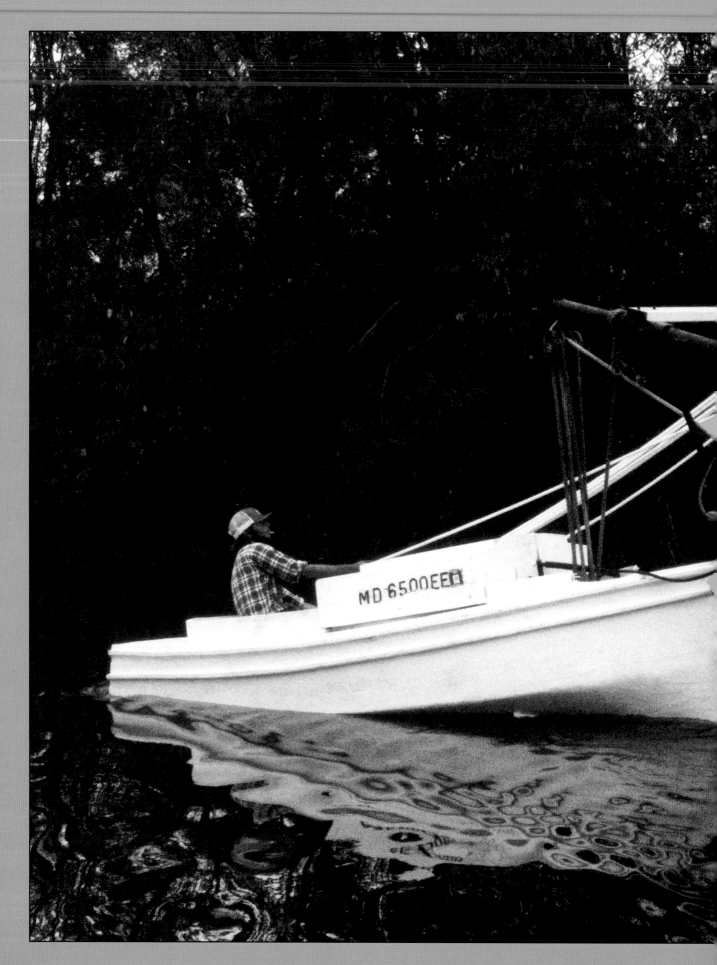

With their repairs complete, Captain Stan and his crew back the Howard out of the "ditch," with the help of the yawl boat.

Tutor finished the new hatch covers fore and aft. We painted them green to match the cabin. Jack built a door to cover the fuse panel in the cabin.

Jim asked if I would vacuum under the deck in the bow. "Wood chips will clog the bilge pump," he explained. I jumped right in there and vacuumed it out.

The new cook stove was delivered. It looked good. I was sure Buster would appreciate the new cabin more than anyone else. He could now stand up without bumping his head and had a new cook stove to boot.

Junior said to me, "So ya saw her from the beginnin' to the end. Next year, we do the front half of the boat."

Stan and his crew were gathered around the *Howard*. They were launching their yawl boat. In minutes, they were backing out of the "ditch," the little channel that runs up to Scott's Cove Marina. I got to see how the push boat is so important for steering and maneuverability. They backed the *Howard* out of the ditch and went back to Wenona for some final preparations for their sail up the bay.

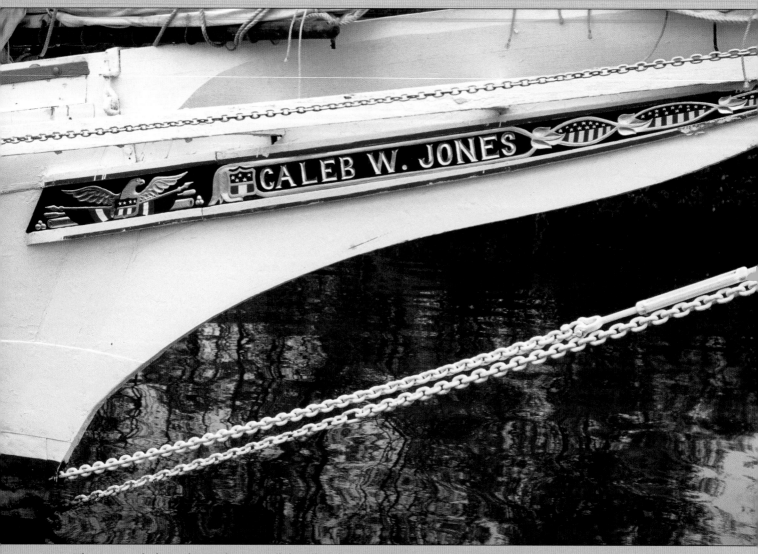

These intricately designed nameplates are called trailboards. Once installed, the Caleb comes to life.

I returned my attentions to the *Caleb*. She was a beautiful sailing vessel. Because Dicky had plenty of other details to worry about in preparation for the upcoming oyster season, he didn't seem to be as concerned with the "finishing touches" as much as Jim, Fountain, and I. We wanted her to look tip-top for our sail up the bay.

Before I left, I asked Dicky if he needed anything from Salisbury. "A garbage can for drinkin' wooter," was his answer. "Preferably new."

On my way home, I thought about the many people who had a hand in this project, and that very soon, Ted and the *Krentz*, Stan and the *Howard*, and Dicky and the *Caleb* would represent Deal Island at Chesapeake Appreciation Days.

"We sail tomorrow!"

Nine

Chesapeake Appreciation Days

It was Friday, October 26. I awoke at 3:00 a.m. to a damp, overcast morning. I hadn't had much sleep because I was excited about my first sailing adventure on the *Caleb W. Jones* since last year's race day, when we broke a bob chain early in the race and had to power back to Sandy Point Harbor. When Fountain picked me up at 3:30 a.m., he looked wound up and ready to go. His brother, Ed, was with him.

From there we picked up our fishing buddy Rodney Pierson, who would drop us off at Chance, then drive to Sandy Point and meet us. We also picked up Jim Coffman, who had all his gear piled on the sidewalk outside his apartment. There he was, pacing away at 3:50 in the morning. Jim is a fairly high-strung individual.

When we arrived at Scott's Cove in Chance at 5:00 a.m., it was pitch black. The clouds blocked any light the stars may have provided. We found Bruce, one of the two regular crew members who would be sailing up the bay with us, sound asleep in his bunk. The noise we all made loading our gear and putting the newly painted hatch covers on board got Bruce up and about.

Fountain and I went to get a fishing rod off my boat at Windsor's Marina. "Ya never know when ya might need one," he said. When we returned to the *Caleb* about 15 minutes later, Captain Dicky was there. Dicky said his stomach was a little upset—understandable, since he had probably reviewed every detail of the boat's preparation in his mind, over and over. While we loaded the remaining gear, Dicky went to get his other regular crewman, Tom. In the meantime, Don Wheatly, a long-time friend of Dicky's, arrived. So that was the regular crew for the sail up the bay—Captain Dicky, Bruce, and Tom. Jim, Fountain, Eddie, Don Wheatly, and I were along for the ride.

After two weeks of hanging around the marina, watching and helping when I could, I was eager to get started. Around 5:45 a.m., we lowered the yawl boat into the water. Bruce jumped in and Dicky gave the orders to cast off. It was so dark, I could hardly see my hand in front of my face. But to my amazement, Captain Dicky maneuvered the *Caleb* out of Scott's Cove and into Tangier Sound effortlessly. He could have done it with his eyes closed.

The continuous rumble of the push boat's engine filled the silence on the water. If the tide had been incoming and the wind out of the south, we could have sailed up noiselessly, but, because of unfavorable winds and tide, we continued to use the push boat.

We were underway for almost an hour before daylight crept in on us. This happened slowly, because thick clouds blocked the sun at the horizon. Bruce and Tom, the regular crew, slept in the cabin. But this was the first long trip for me and most of the other guys, so we weren't about to miss anything.

Since Bruce and Tom were snoozing in their bunks, Dicky asked for a volunteer to unfasten the jib on the bowsprit to increase our use of the available winds. Realizing that none of us were thrilled about the prospect of climbing out on the damp, slippery bowsprit while the *Caleb* was cruising at about 8 knots, Dicky handled the job himself. He shimmied out on the bowsprit on his butt and untied the jib, making it look easy.

Buster, the *Caleb's* regular cook, was not due to join the boat until later, so Jim and I proceeded to cook up some serious bacon and eggs. The task was relatively easy considering the boat swayed only slightly from the motion of light winds, waves, and tide. The new cook stove was nice to work with. Also used to heat the cabin, the little stove

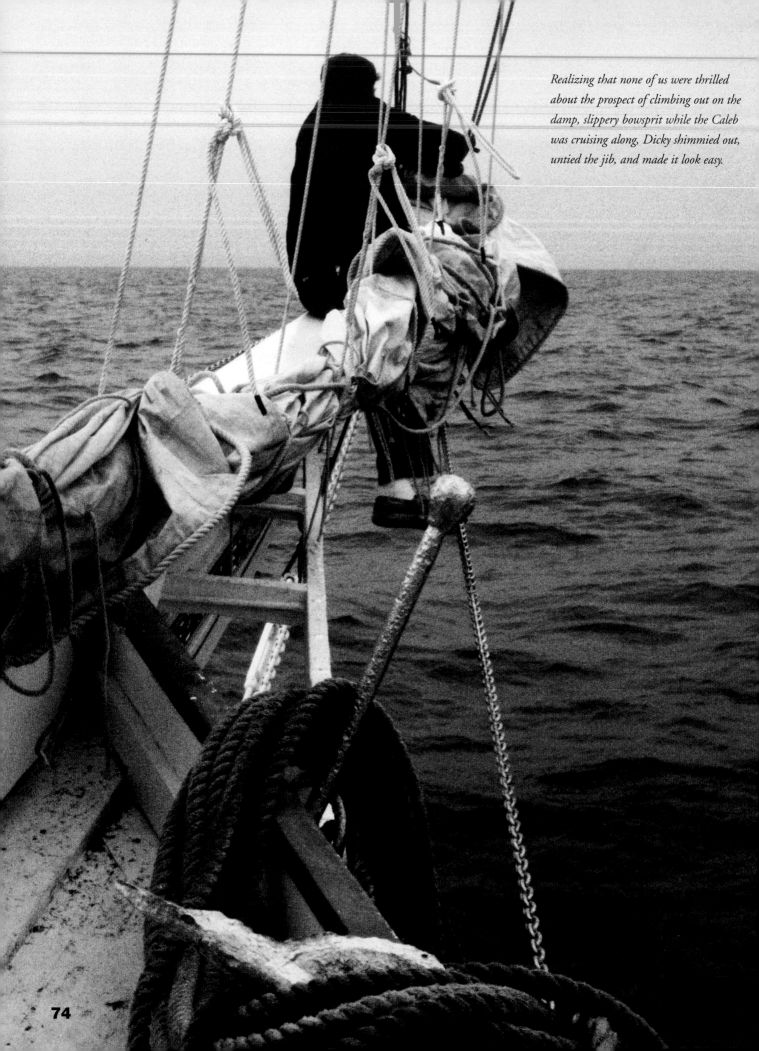

Realizing that none of us were thrilled about the prospect of climbing out on the damp, slippery bowsprit while the Caleb was cruising along, Dicky shimmied out, untied the jib, and made it look easy.

seemed capable of keeping the place toasty all winter long. I was sure Buster would find his new surroundings more comfortable and a little easier than in some years gone by. Plenty of cabin space, more ventilation, and a brand new stove.

Shortly after breakfast, the clouds began to break up and a little warming sunshine broke through. Fountain, Jim, Ed, and I went to work again, installing and fastening the protective sideboards needed to help keep oysters and men from falling overboard. Then we began to make the *Caleb* shine by scrubbing down the deck. It seems impossible to make a working Skipjack shine, but the *Caleb* was about as clean as she could get . . . a boat we were proud to sail into Sandy Point Harbor.

The rest of the day was tremendous. The clouds all but disappeared and the sun warmed us. A few of us took off our shirts to catch some rays, and we all relaxed.

Dicky gave us a turn at the helm if we wanted, told us what direction to take, and occasionally pointed out landmarks. The work was done, so, during the eight-hour sail up the bay to Sandy Point, we all talked, laughed, and shared a few beers.

Don Wheatly saw that I was taking all the pictures and so he snapped one of the group with me included. I'm glad he did. That picture will be a great reminder of a wonderful trip for many years.

Lunch was fast and easy: ham and cheese appetizers, and hamburgers for the main course. After lunch, Jim and Fountain tinkered with the connections of the CB radio. Dicky had been getting poor reception and was hardly reaching Stan on the *Howard*, sailing about an hour ahead of us. Fountain even tried to get his cellular phone to work. Don Wheatly kept trying but could not reach Ted aboard the *H. M. Krentz* by radio, either.

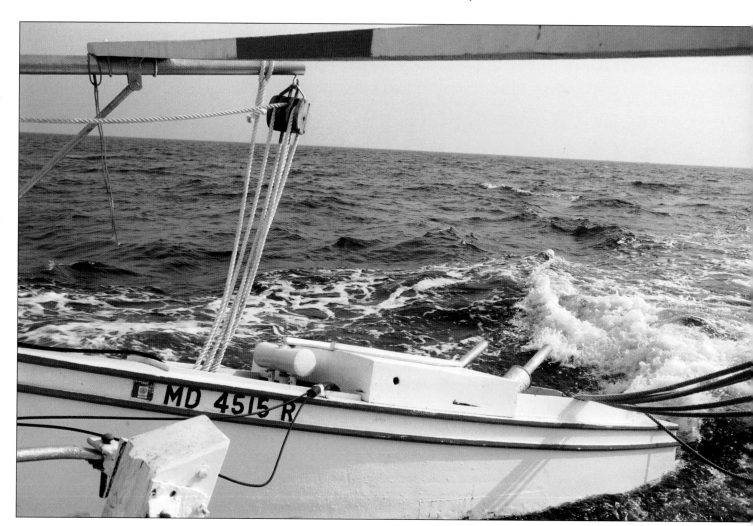

We had to appreciate the consistency and power of the little yawl boat that pushed us up the bay for eight hours.

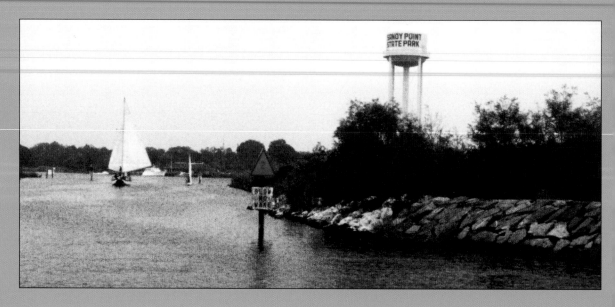

The sight of so many Skipjacks in one place was grand!

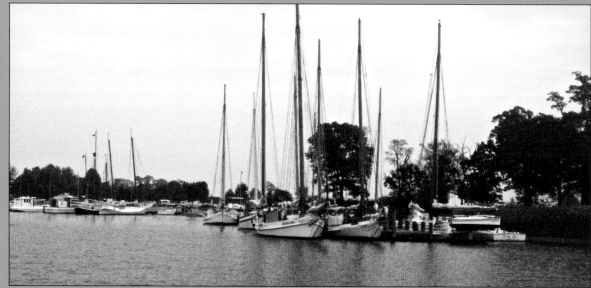

"It looks like the entire fleet."

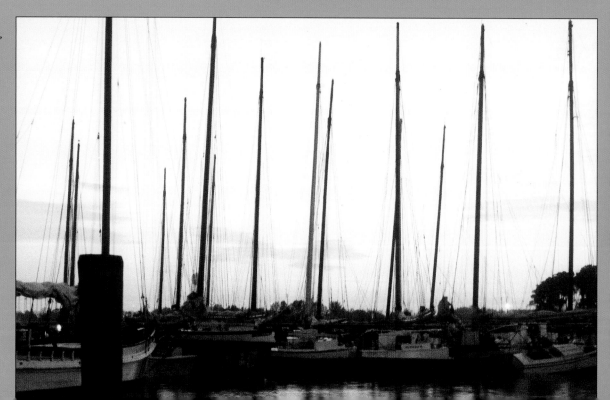

As we sailed north to Sandy Point, Fountain tried trolling for a while with my fishing rod. What a fishing maniac that guy is. He does love to fish. With no luck, he got bored and gave up. We were moving too fast to catch anything.

Just a little wind at our backs would have made the trip more pleasant. We could have hauled in the push boat and glided up the bay with only the sound of the wind in the sails and the water caressing the hull. As it was, we had to appreciate the consistency and power of the little yawl boat that pushed us up the bay for eight hours.

Captain Dicky said we could have made it without the extra help, but it would have taken us several more hours and a lot of tacking.

As we neared our final destination, several oil tankers and navy ships came into view. One guy in a large pleasure sailboat climbed out onto his bowsprit to get a picture of the *Caleb* as we sailed by. I got a picture of him, too.

As we passed Thomas Point lighthouse, I wondered about the men who lived on these man-made islands for months— sometimes years—at a time. The isolation and the weather had to make their lives extremely uncomfortable and difficult. Surely, it took a rare man to fill that job. Dicky told me that in order to make their lives somewhat more bearable, the lighthouse keeper's family would, on occasion, live in the lighthouse with the keeper.

A rolling mass of clouds suddenly blocked out the sun as the Chesapeake Bay Bridge came into view. As we grew closer, the massive, gray, steel structure towered over us, monstrous and intimidating. A moment later it completely surrounded us.

Just on the other side of the bridge was our destination, Sandy Point State Park.

Captain Dicky guided the *Caleb* into the marina with his usual skill and grace. The sight of so many Skipjacks in one place was grand! There must have been fifteen or sixteen of them, side by side in the harbor, their masts stretching into the sky.

*Relaxing and having fun
at the helm is Dicky's payoff
for so much hard work.*

"It looks like the entire fleet," I said. Dicky responded by recalling a time in Annapolis Harbor when he could walk across the decks of Skipjacks as they were tied up side by side, for what seemed like hours.

Almost everyone who gathered on the docks to look at these living legends came equipped with a camera. I decided to enjoy the weekend and the races and not worry about recording this event on film, as literally hundreds of people would do so. The *working* Skipjack was my subject.

Ten or twelve Skipjack captains with their crews and passengers raced on Saturday. The wind was relatively light, which gave the advantage to the smaller, lighter boats in the race. Dicky asked Bruce to take a long board and hold the *Caleb's* jib out as far as it would go to catch as much wind as possible. It may have helped a little. We placed a respectable third, and it was an exciting race. But, throughout the day, I found myself looking forward to being aboard the *Caleb* when she was dredging oysters. That is what she was built for.

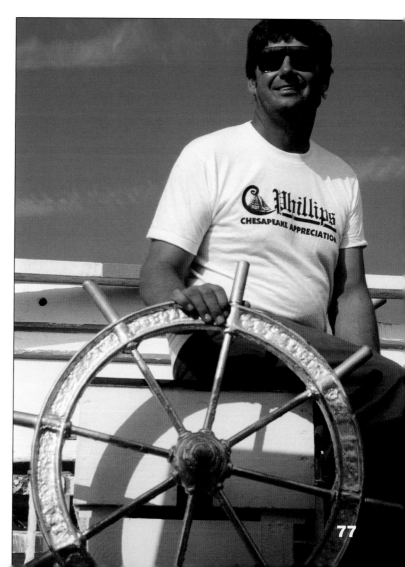

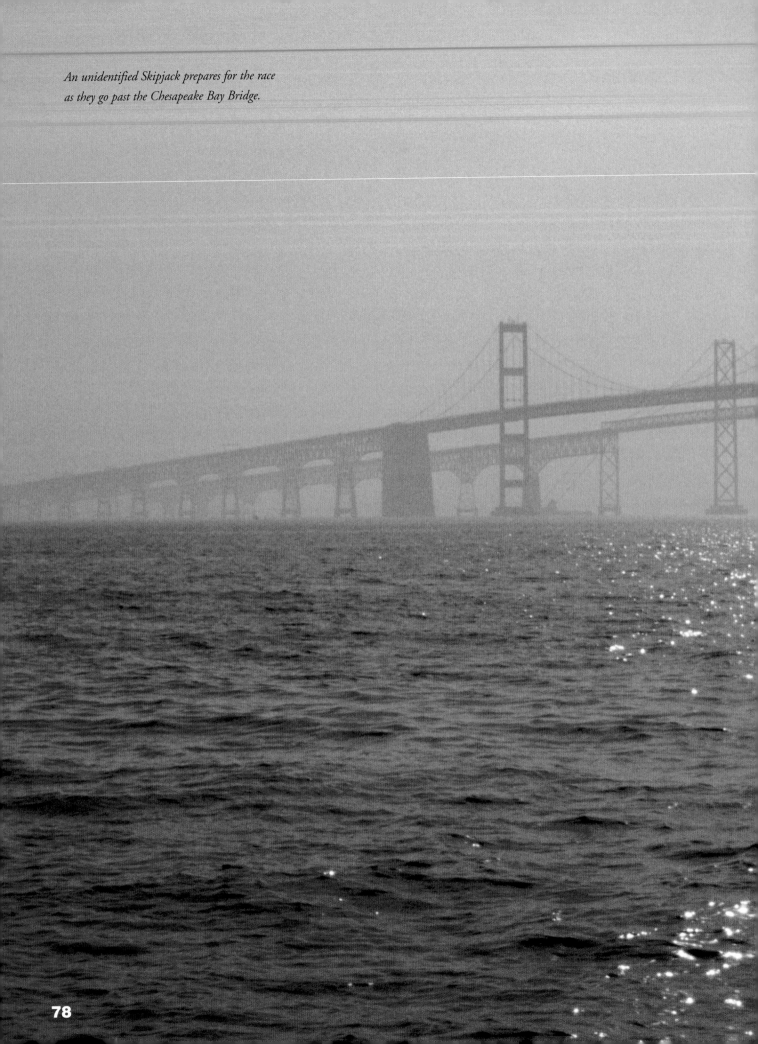

An unidentified Skipjack prepares for the race
as they go past the Chesapeake Bay Bridge.

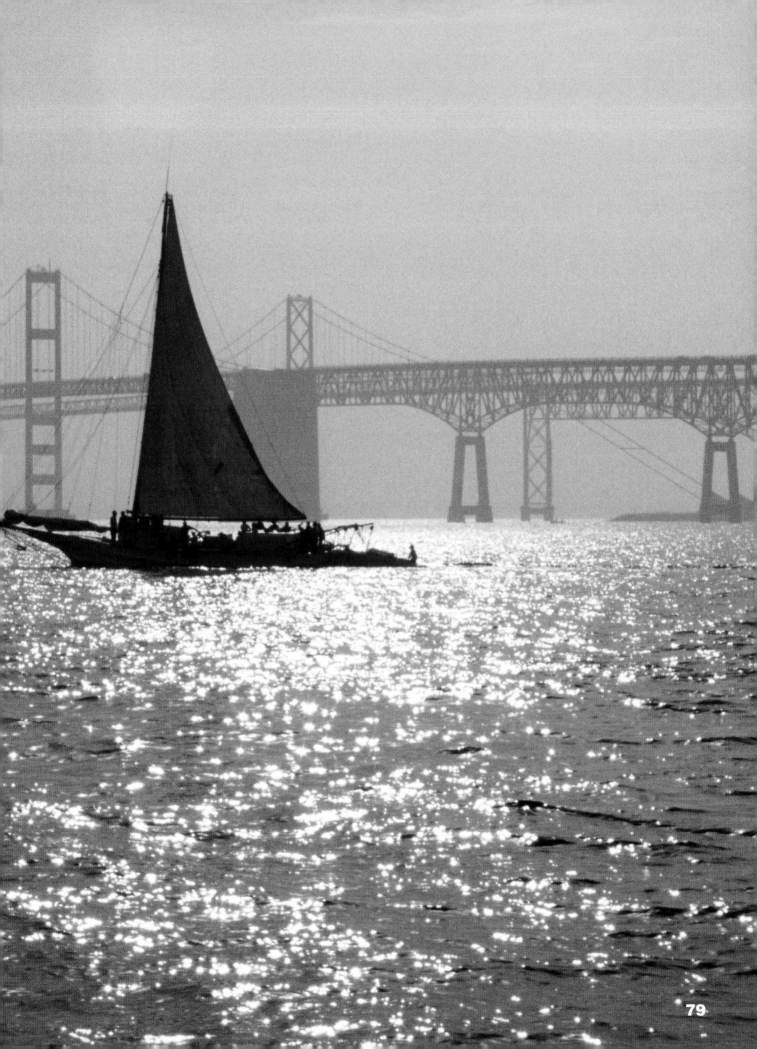

Coming into port, Bruce helps Dicky maneuver the Caleb.

Ten

Cambridge Harbor

I began the day with a shopping trip to J. C. Penny in downtown Salisbury. It was the seventh of November, 1984. Dicky had suggested that I purchase some long underwear and wool socks. "If yer gonna sail with me, you have to dress right so you don't get cold," he said. While I was downtown, I stopped by to see Don Wheatly at work to give him a black-and-white picture of the *Caleb*. He seemed surprised and thanked me.

Dicky always sails out of Cambridge Harbor for the first month or two of the season each year, so I planned to meet up with him in Cambridge to find out if he would be out on the Choptank River the next day. He told me during the rebuilding of the *Caleb* that he starts dredging season on the Choptank River every year. Late that afternoon, Jim Coffman rode with me, and we arrived before Dicky and the *Caleb* were back in the harbor. The sun was setting and a full moon was rising to the east when Dicky powered his boat into port. His crewman, Bruce, was in the yawl boat helping Dicky maneuver the *Caleb*. Right behind them was his brother Ted on the *H. M. Krentz*.

I was experimenting with 1600 ASA push film and photographed the *Caleb* as she approached the docks, finishing off the roll while Dicky docked the boat. There wasn't a lot of light left in the day, so I used the fast film to avoid using a flash, thus getting more flexibility with what I could successfully photograph from a distance.

Only minutes after the two boats had tied up at the dock, a marine policeman came aboard to check the day's catch for size violations. Dicky told me the Marine Police check everybody and can fine the captain if more than five percent of the oysters are undersized. "Some people want to make it so a captain can lose his license or get it suspended with an accumulation of violations," he explained.

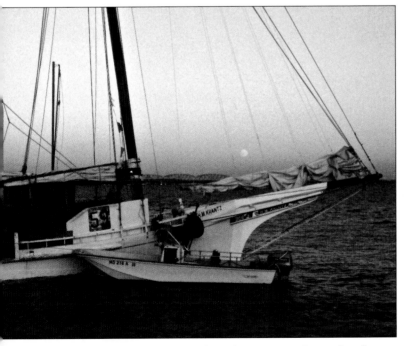
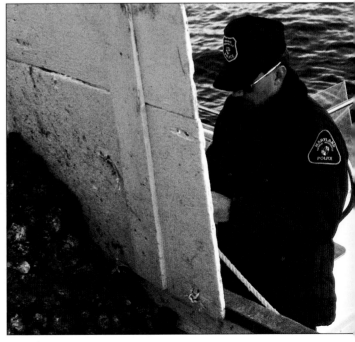

The Marine Police check every haul, and can fine a captain if more than five percent of the oysters are undersized.

*The Caleb in Cambridge, a place where tradition
and honor live side-by-side with progress and change.*

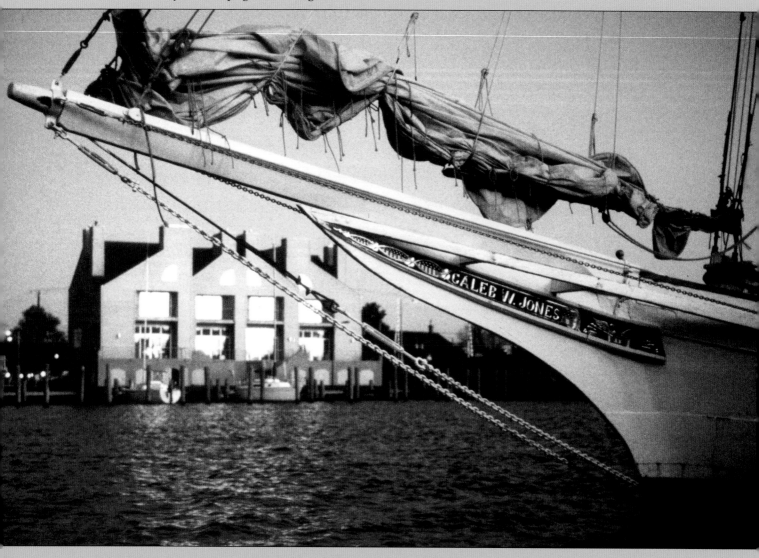

A 350th celebration flag was still hanging from the
Caleb's rigging. In the background was the *Krentz*, waiting
for her turn to unload.

Before we left, Jim installed the depth finder he had
repaired for Captain Dicky. While he was busy, I asked
Dicky if he planned on working out of Cambridge the next
day, and told him Fountain and I wanted to come down in
my boat.

His answer was, "Yes."

Eleven

"Slick Cam"

Fountain and I launched my boat, the *Cash Flow*, at the public ramp in Cambridge and rode the twenty or so minutes to Hal's Point where six or seven Skipjacks were working. Someone aboard the *Rebecca T. Ruark* was up the mast in the bosn's chair. They were apparently having some trouble with the rigging.

The sky was crystal clear and the temperature right. Unfortunately for Captain Dicky, the crew of the *Caleb,* and the other watermen on their Skipjacks, it was not a good day for dredging at all. There wasn't a breath of wind. The occasional slight breeze wasn't even enough to fill the sails of the dredge boats. They were sitting as though they were anchored. "Slick cam," as Dicky would say.

We circled the *Caleb* a couple of times. Not seeing much happening, we went to troll for rockfish in the little creek nearby. Dicky told us that he had seen some fish breaking water there earlier in the week.

We didn't have any luck with the fishing, but the scenery was superb. There were some magnificent homes on the lagoon off the creek, and a finger of land that bordered the lagoon reminded us of a deserted island. The white sand was smooth and clean and the water was clear.

By the time we got back to the *Caleb*, her sails were down and she was headed towards the harbor, the little yawl boat doing its job pushing her in. Halfway back to the harbor, we tied to the stern of the *Caleb* and climbed aboard for a short ride. Dicky commented, "There wasn't even enough wind to pull just one dredge, never mind two," so they called it an early day. They did have some oysters on board and Dicky told me there had been a little wind earlier. "But what little there was fell out to nothin'," he said.

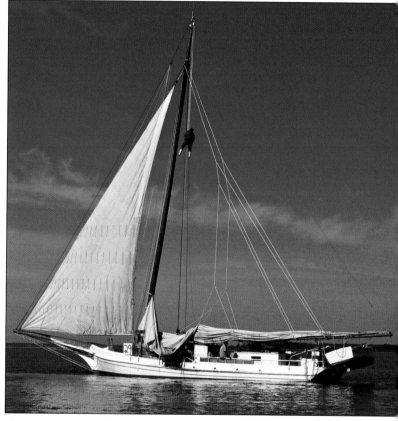

A crewman goes up the mast on the bos'n's chair aboard the Rebecca T. Ruark.

When we neared the harbor, Fountain and I cast off in my boat so I could get some photos of the *Caleb* approaching the dock where she unloads her catch. Ted and the *Krentz* were already there.

After Dicky made her fast, he discovered that his usual buyer wasn't buying today because the shuckers had plenty of oysters. His only alternative was to call down to Crisfield for a truck to come and pick up their catch . . . an additional three hour wait for the crew. Of course, the Marine Police were there in the meantime for their usual inspection for size violations.

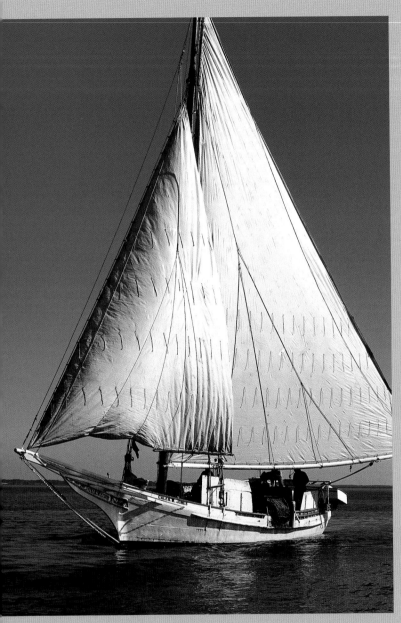

There wasn't a breath of wind, and they sat as though anchored.

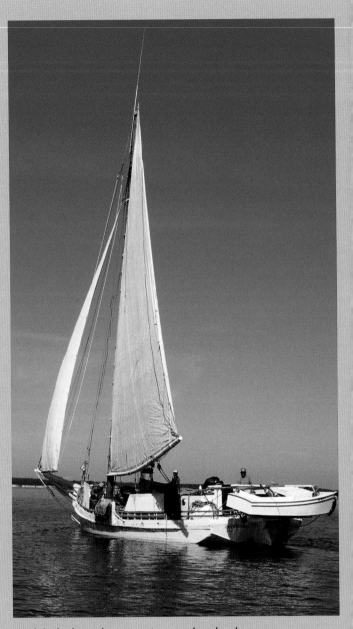

With little else to do, it was time to take a break.

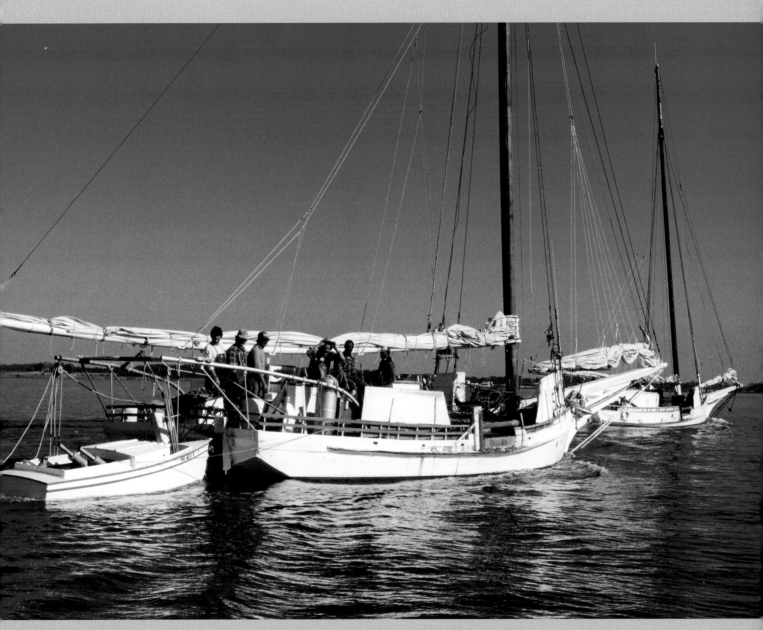

By the time we got back to the Caleb, her sails were down and she was headed toward the harbor.

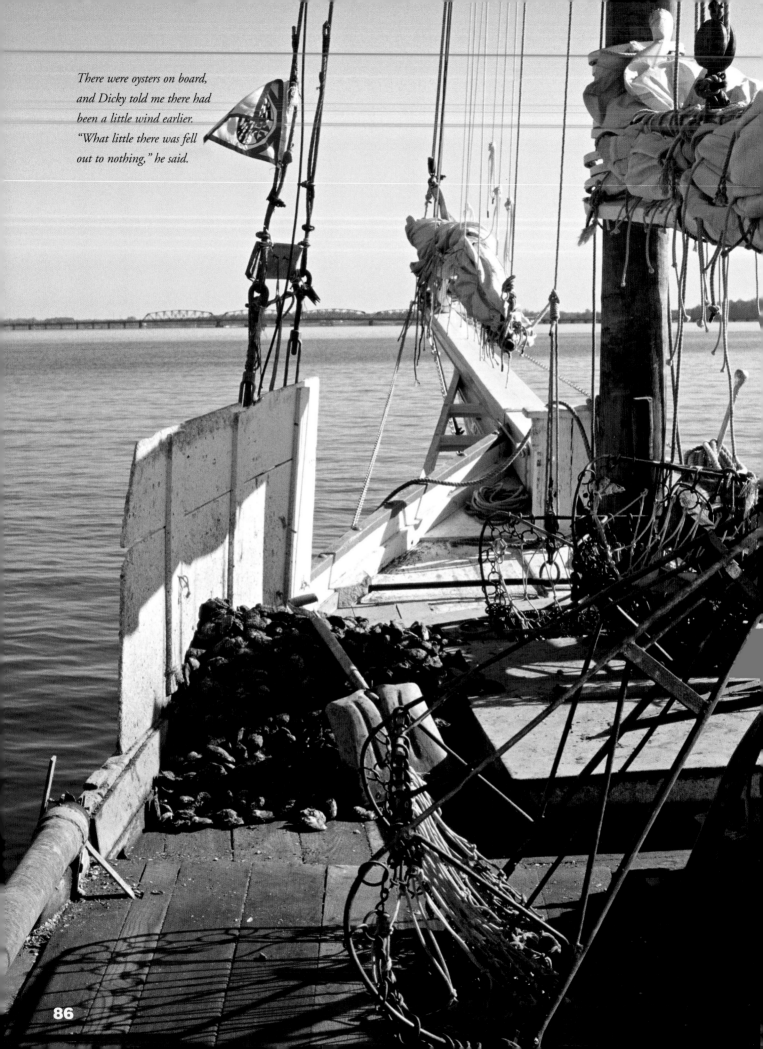

There were oysters on board,
and Dicky told me there had
been a little wind earlier.
"What little there was fell
out to nothing," he said.

Twelve

Plenty of Wind

The following week, November 15, Mark Engberg, an old friend, accompanied me to Cambridge and the Choptank River to ride out to the Skipjacks and take some pictures. Looking back, it seemed inevitable that Mark and I would grow up as good friends. Our backgrounds were similar in many ways. We both were born and raised in Salisbury, lived within walking distance of the Wicomico River, went to the same school, and had the same friends. Most compelling, however, is that both of our fathers had boats and both of our fathers took us boating and fishing from a very early age. They taught us how to use boats when we were young, and those experiences opened our eyes to the many wonders of the bay. When we were old enough to operate the boats ourselves, Mark and his brother, John, taught me how to water ski. Ever since then we've spent many memorable days together on the bay and its tributaries, skiing, fishing, exploring, or just joy riding. Another great day on the water was in store for us.

We left Salisbury around 11:00 a.m. towing the *Cash Flow*. It was a late start, but neither of us had to be back at a certain time. Mark and I arrived in Cambridge around noon and launched the boat at the public ramp. We were away from the dock for only three or four minutes when the boat started to act up again. The *Cash Flow* had been running a little rough and had been in the shop a couple of times, but evidently it still was not fixed. I had a notion that the problem was in the fuel flow, so Mark cleaned the gas filter and fastened the hoses that the boat mechanic forgot to put back on after he changed the boat's thermostat. After this adjustment, the motor ran great and, as we headed away from the harbor, I felt a new appreciation for Mark's skills as a marine mechanic.

There was just the right amount of wind for dredging oysters. The captains had their sails reefed in and were moving along at a good speed.

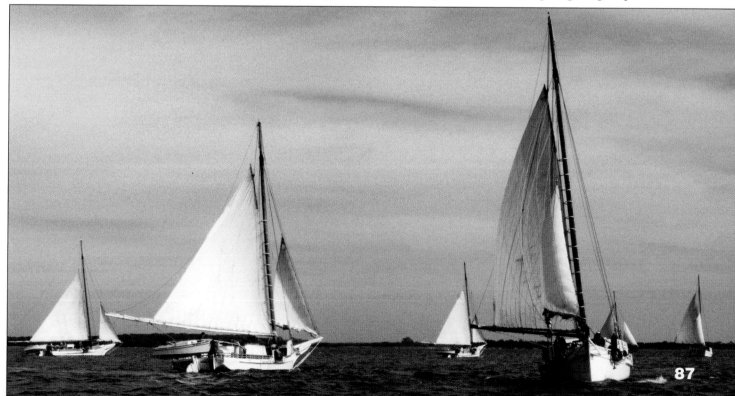

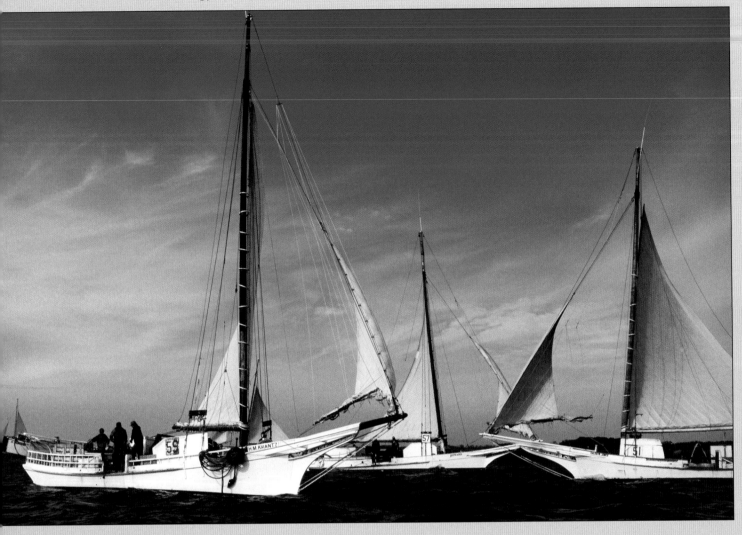

As we approached the Skipjacks, Mark and I counted twelve of them. They were in two groups, eight in one and four in the other. The *Caleb W. Jones* was in the larger group, closer to the mouth of the river. We got close enough to say hello and I broke out my camera. There was just the right amount of wind for dredging oysters with Skipjacks under sail. The captains had their sails reefed in, and they were moving along at a good speed.

Mark took the wheel of my boat while I photographed the watermen at work on their dredge boats. Once again, I was impressed to see just how close to one another the boats were working. We could hear the men talking from boat to boat as they passed one another. We concentrated our photo session on the *Caleb* and Captain Dicky. As we watched these men dredging the oyster bar at the bottom of the Choptank River, a sense of history in the making overwhelmed the two of us. We were witnessing the continuance of a tradition, of a way of life that has remained relatively unchanged for over a century: dredging oysters with America's few remaining commercial sailing vessels, the Skipjacks!

I shot film for a couple of hours before we went up the nearby creek that Fountain and I had explored earlier in the week. Mark was just as impressed with the scenery and the beautiful homes along the water's edge as I had been.

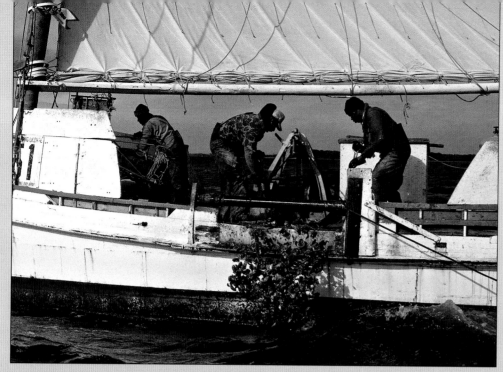

The crew shovels shells, rocks, and undersized oysters back into the river.

Captain Dicky pilots the Caleb over the oyster bar for another "lick."

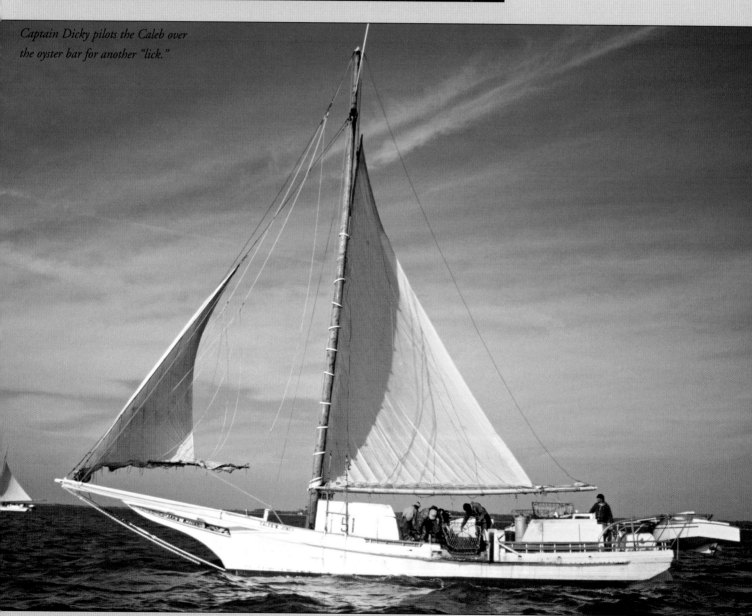

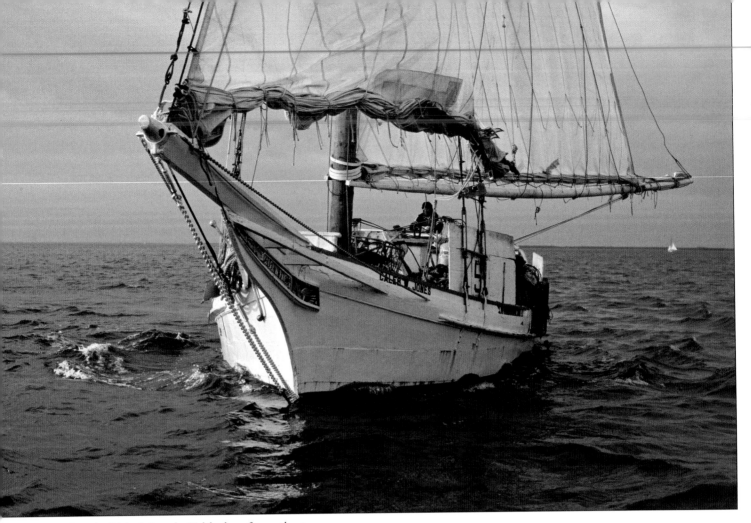

Captain Dicky brings the Caleb about for another pass.

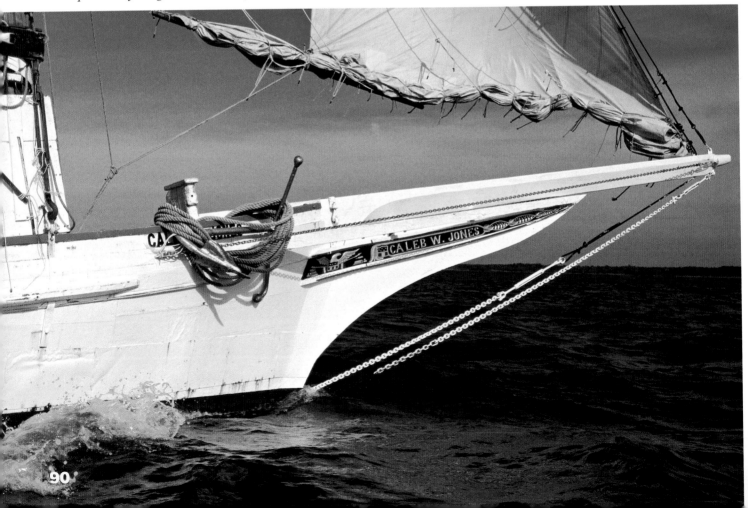

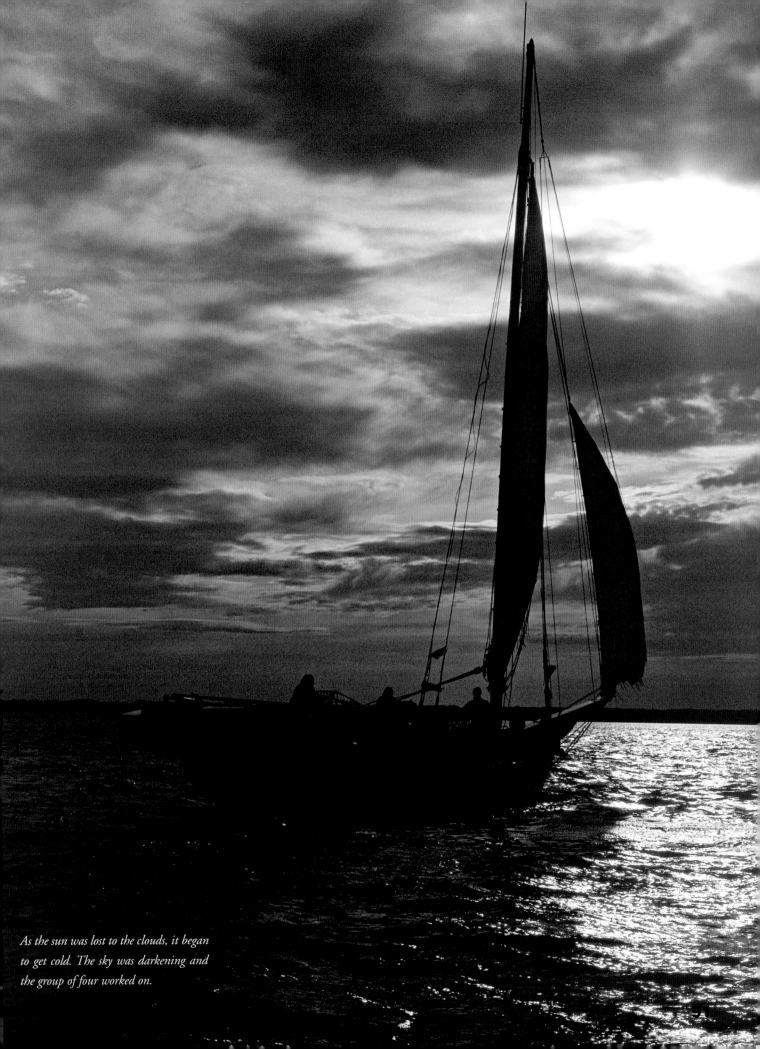

As the sun was lost to the clouds, it began to get cold. The sky was darkening and the group of four worked on.

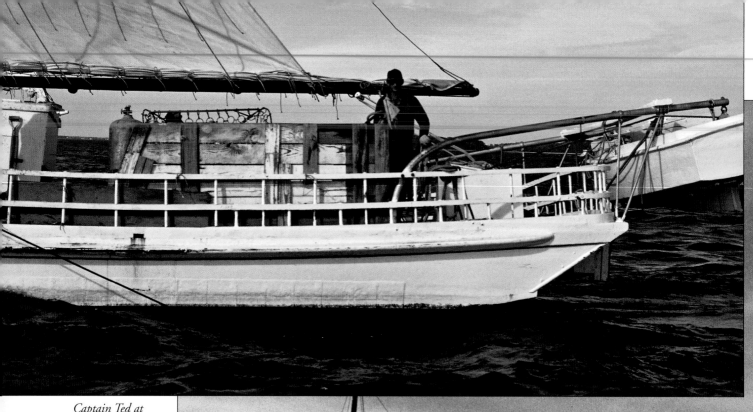

*Captain Ted at
the helm of the
H.M. Krentz.*

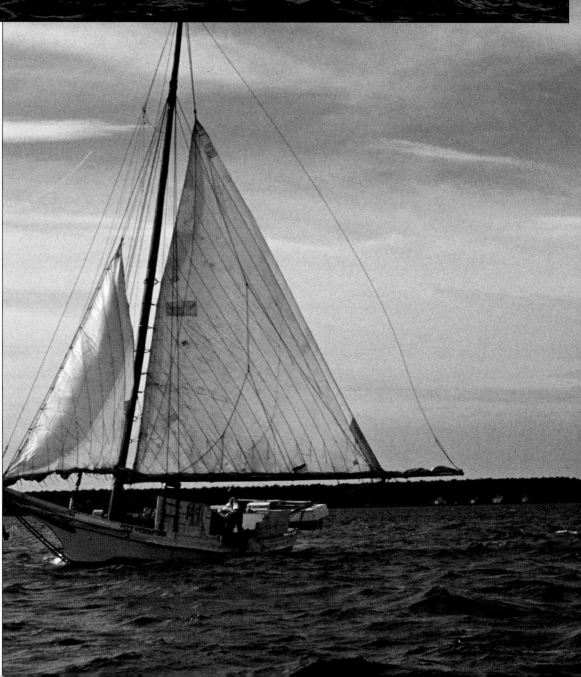

We were witnessing the continuance of a tradition, of a way of life that has remained relatively unchanged for more than a century.

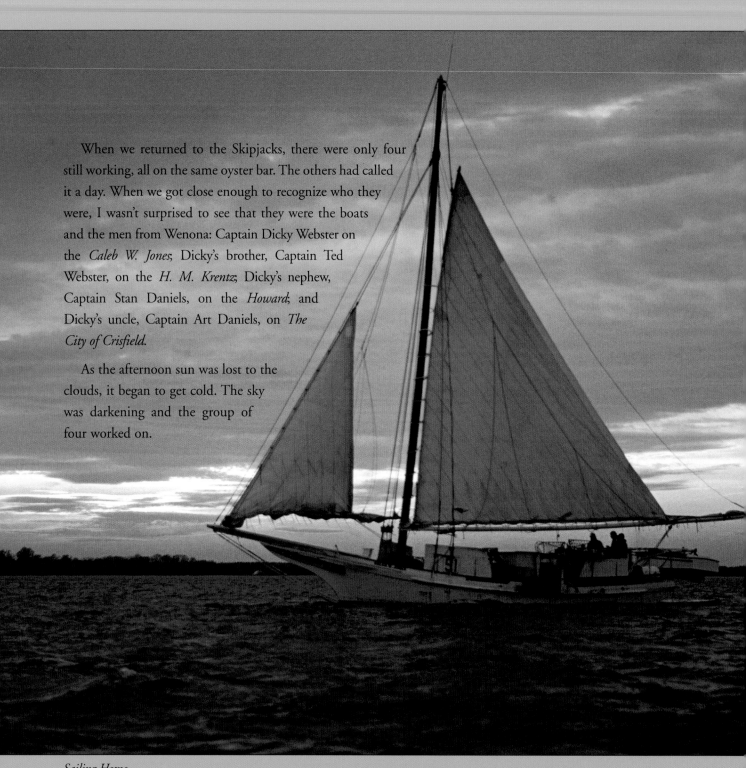

When we returned to the Skipjacks, there were only four still working, all on the same oyster bar. The others had called it a day. When we got close enough to recognize who they were, I wasn't surprised to see that they were the boats and the men from Wenona: Captain Dicky Webster on the *Caleb W. Jones*; Dicky's brother, Captain Ted Webster, on the *H. M. Krentz*; Dicky's nephew, Captain Stan Daniels, on the *Howard*; and Dicky's uncle, Captain Art Daniels, on *The City of Crisfield*.

As the afternoon sun was lost to the clouds, it began to get cold. The sky was darkening and the group of four worked on.

Sailing Home

Thirteen

Thanksgiving Day

During an excursion on the Choptank River with Captain Dicky, I had mentioned that I would like to photograph the "unloading of the catch" at the dock. However, photographing the unloading process presented a slight problem. Dicky and his crew usually worked through to dusk, and there wasn't enough light left in the day to get the pictures I wanted by the time they returned to port.

Dicky had told me how watermen are at the mercy of the middlemen or "buyers" at the docks. The price these buyers pay the watermen for their oysters fluctuates with market conditions. I recalled a recent incident when Captain Dicky returned to the harbor only to discover that there was no market at all for his catch.

As previously mentioned, in years past, in contrast to today, most middlemen had their own boats called buy boats. The oystermen didn't have to return to port to sell their catch. They simply met up with a buy boat out on the water and sold their catch to the buy boat captain at that day's market rate. The buy boat captains, in turn, would deliver the oysters to ports of call, such as Baltimore or Crisfield, and sell them ashore. Today, there are far fewer buy boats in operation. But there are a few.

Dicky was the one who came up with the solution: "We're only workin' half a day on Thanksgiving. Why don't you sail with us?" he asked. "We sail out of Cambridge."

"Sounds good to me," I replied.

Thanksgiving turned out to be bitter cold, particularly in the pre-dawn hours. I dressed as warmly as I knew how, with several layers of clothing, waterproof boots over my sneakers and two pairs of socks. Climbing out of my truck and heading toward the *Caleb*, I wondered, "What motivates these men to go out on a boat during the coldest part of the year, day after day, year after year?" It had to be more than a day's work for a day's wage.

Captain Dicky, Clyde, and Buster greeted me when I arrived. Accompanying them were two new crew members. Judging by what Dicky had told me of his past experiences, these newcomers probably wouldn't be around for long. Keeping a good crew was one of the hardest parts of his job. Even from my limited experience on board, I could understand why crewmen move on. The work is backbreaking, and the weather conditions are often miserable.

"It's even more difficult late in the season when the weather is more severe and the crew has some money in their pockets," said Captain Dicky.

As the watermen prepared to sail, I noticed they wore winter hats and insulated coveralls over their regular clothes. On top of the coveralls, they wore waterproof oilskins. Their boots looked insulated and waterproof, too. As I walked around the boat, I couldn't help noticing the exquisite heat radiating from the cabin. I poked my head in and felt the trusty little cook stove cranking it out.

Captain Dicky ponders which oyster bar he would try first.

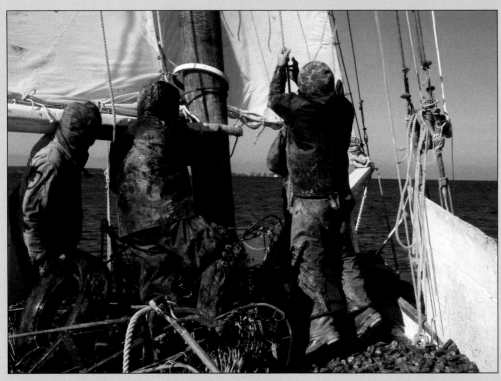

Two crewmen push upward on the boom while the other two pull on the rope with all their weight to hoist the sail to its highest point..

This is really a hands-and-knees kind of job.

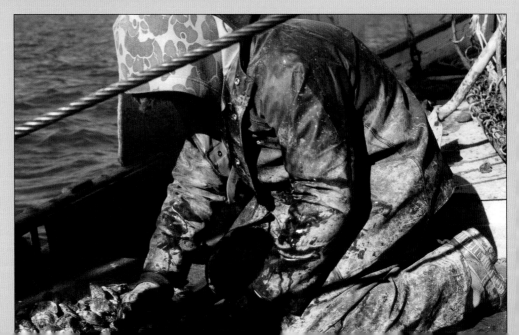

As the sun began to rise, Captain Dicky gave the word to his crew and we headed out. It was quiet. The only sounds were the wind in the sails and the water caressing the hull. It wasn't long before Dicky was on the marine radio with Captain Stan on the *Howard* to talk things over and decide which oyster bar they would try.

When we reached our destination, the crew dropped both dredges overboard on the captain's order. Using only the wind for locomotion, the *Caleb* began to pull the dredges over the oyster bar. The cold, steady breeze and the smell of the salty sea air was invigorating. Every now and then, Dicky instructed his crew how to position the sails, and they made the necessary adjustments.

All of a sudden I heard a loud engine start up. It was the engine used to pull the dredges back in. "Wouldn't want to get caught up in that cable," I said to no one in particular. Dicky heard and recalled that in the early days of dredging oysters, the crew pulled the dredges in by hand, using a windlass, a horizontal barrel supported on vertical posts and turned by a crank so the hoisting rope wound around the barrel. It took four men to wind in each dredge. I imagined no loud engines; just the sounds of men working the arduous job of cranking in the dredges, the wind in the sails, the water on the hull and the seagulls following behind the boat.

My thoughts came back to the present and the work of these men. When the first dredge came up, Buster and Clyde dumped its contents on the deck and began to cull the oysters. There is no one correct way to do this, and each man seemed to use a different method. To my surprise, what looked like a load of oysters on the first lick, or pass over the oyster bed, ended up only a dozen or so. The rest consisted of empty shells, undersized oysters, rocks, mud, and other debris, including an occasional crab.

After Buster and Clyde had culled for a few minutes, Dicky asked Buster to drop the dredge back overboard. Then he motioned to the crewman on the other side of the *Caleb* to start winding in the second dredge. When it came up, it too was dumped on the deck, the good oysters separated out. Everything else was shoveled back into the river.

That's the way the morning went. Alternating back and forth, the crew kept very busy. Captain Dicky stayed busy, too. He found the oyster bars and kept the *Caleb* positioned over them while contending with the wind, the tide, the other boats working in the area and the varying degrees of resistance from the dredges as the *Caleb* pulled them across the bottom. Sometimes the dredges worked like anchors when they got snagged on something. Dicky told me, "Many a dredge has been lost or damaged at the bottom of the bay." Other times, the Caleb's direction would change as the crew wound in one or the other dredge.

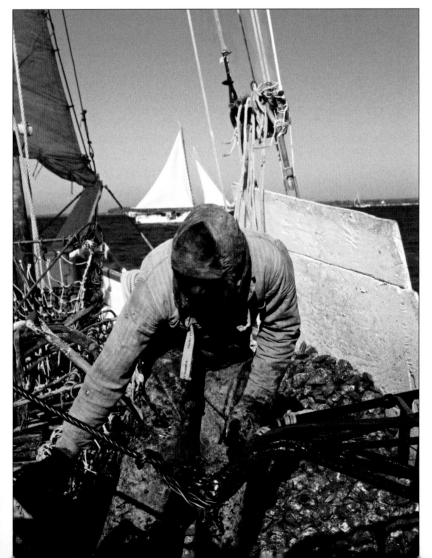

On Captain Dicky's orders,
Buster controls the motor
that pulls the dredge in.

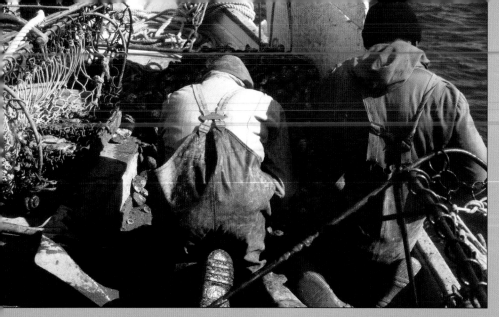

There is no one correct way to cull the oysters.

Rocks, empty shells, oysters, mud, debris, and an occasional crab were among the contents dumped onto the deck to be culled.

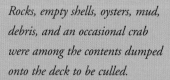

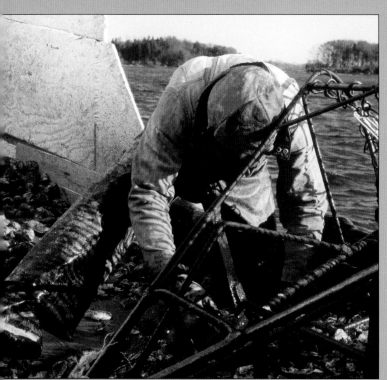

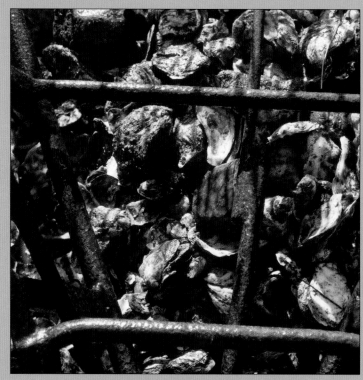

Each man seemed to use a different method.

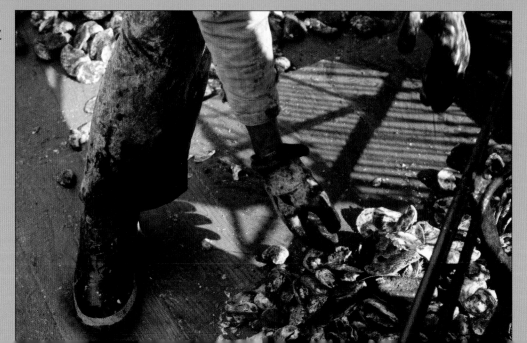

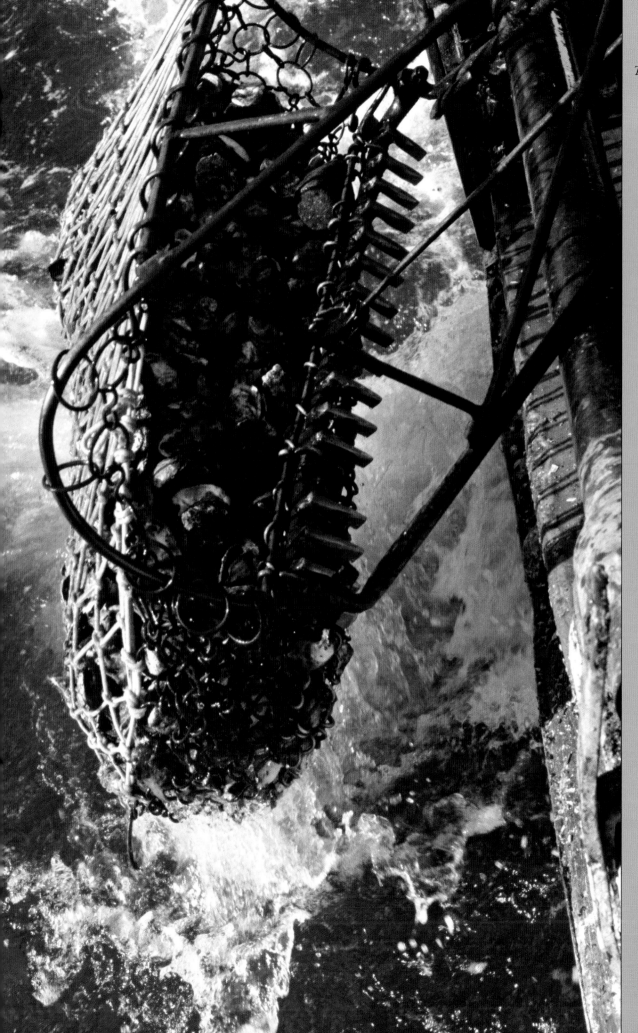

Dicky used one little trick when he had a particularly good lick over an area. He threw out a plastic buoy to mark the spot so he could easily find it again. When I asked Dicky how he found the oysters in the first place, he said that the depth finder was his most useful tool. He looked for what he called "hills" on the bottom.

I kept busy taking pictures and asking questions until the cold set into my hands and feet. I tried to warm up by culling after a dredge was emptied on deck. When that didn't help much, I found my way to the cabin for a short break.

The rest of the morning passed quickly. It was almost noon when Captain Dicky called it quits and we headed back to port. We had what looked like a fair amount of oysters on board. During the return trip, Dicky asked the crew to cull their catch again to reduce the possibility of getting fined by the Marine Police for harvesting under-sized oysters. This second cull was necessary because the crew gets paid according to the number of bushels caught, and they are therefore inclined to be a little less precise on the size restrictions then the captain would like.

Clyde holds a magnificent oyster, just about as big as they get.

To make their task a little easier, the crew used a small, hammer-like tool to separate and measure the oysters.

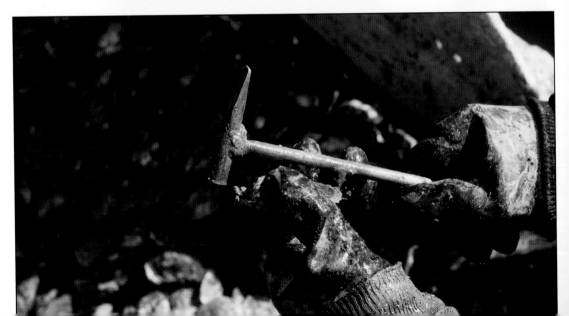

"The captain is the one who gets fined if the percentage of undersized oysters taken exceeds the limit," Captain Dicky told me. "And if it happens repeatedly, they'll take his license! Besides," he continued with a concerned look on his face, "if everybody kept the little ones, there wouldn't be any left for next year." To make their task a little easier, the crew used a small, hammer-like tool to separate and measure the oysters. Clyde called my name and held up a magnificent oyster that was as big as his hand. By the time the crew was finished, we had some fine-looking oysters.

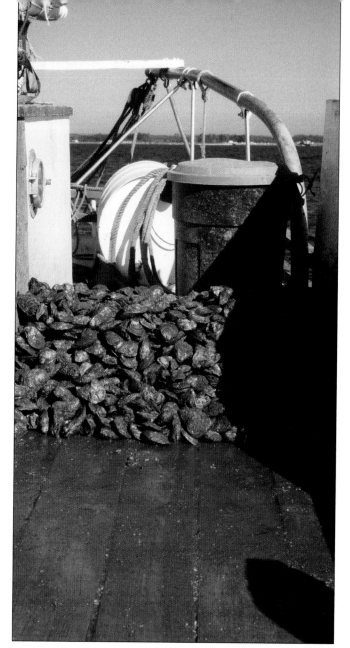

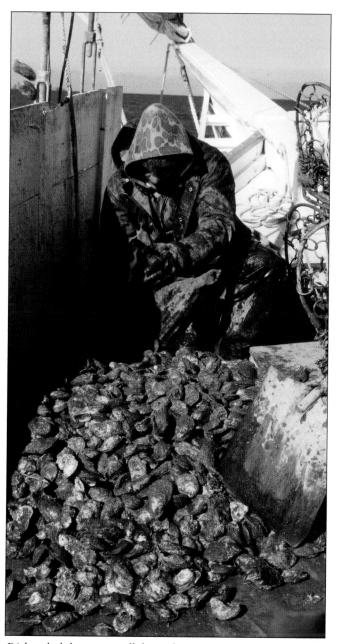

Dicky asked the crew to cull the catch again.
Here a crewman throws three small oysters overboard.

We had what looked like a fair amount of oysters on board.

The day had warmed a little by the time we returned to the harbor. Ahead of us, docked at the place where the oysters are unloaded, was the Skipjack *Wilma Lee*. She, too, was looking good with a fresh coat of paint. When it was our turn, Captain Dicky guided the *Caleb* up to the bulkhead.

Before us stood two men wearing insulated coveralls and heavy boots. These men were oyster buyers. I was standing next to Dicky when he compared these buyers to the buyers of the old days. "The major difference in this part of the oyster business is that middlemen now use trucks instead of buyboats to transport the oysters to market. They can get'm there quicker, too!" He went on to say, "These oysters could be in a restaurant in Philadelphia or New York by tonight."

As the buyers greeted us, it was apparent by the smiles that they knew Dicky and had done business with him before. After a brief conversation about the weather and the day's catch, the crew went to work unloading the oysters.

There were only about twenty feet separating the *Caleb* from the truck used to transport the oysters to market. Between the two was a conveyor belt, and overhead was a boom with some pulleys and a rope leading to a metal bucket the size of a bushel basket. The basket was lowered onto the *Caleb's* deck and the crew quickly filled it with oysters. The men used very large shovels and it took only three or four shovelfuls to make a bushel. After the bucket was full, the man who was standing at the end of the conveyor belt pulled a lever and, with hydraulics instead of physical

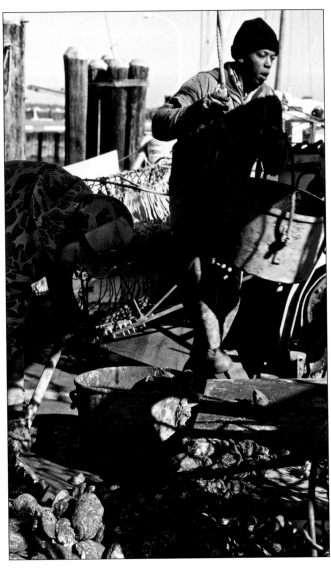

It was apparent by their smiles that they knew Dicky and had done business with him before.

It took only three or four shovelfuls to make a bushel and we had thirty-three bushels before the loading was complete.

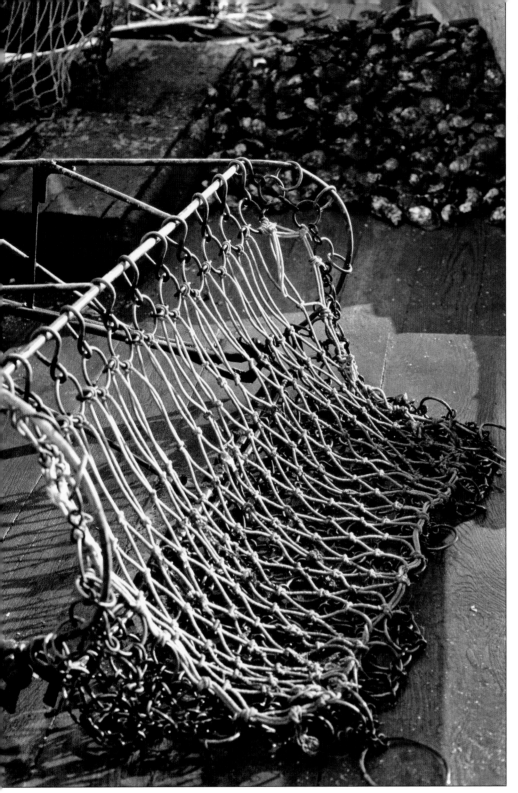

"These oysters could be in a restaurant in Philadelphia or New York by tonight."

"Everything goes on shares now, with one extra share for the boat for maintenance and expenses."

Before I left, Dicky handed me the oysters that he had put aside for me to take home. "They'll be great appetizers for our Thanksgiving dinner," I told him. "Thanks for having me aboard."

exertion, lifted the heavy oysters up high enough to be dumped by another crewman onto the conveyor. From there the conveyor did the work getting the oysters into the truck. This process was repeated thirty-three times before the loading was complete.

The middleman paid Captain Dicky and he in turn gave the crew their shares, keeping one share for himself and one share for the boat. "That's the way it's done," he told me.

On my way back to Salisbury, I began to understand why Captain Dicky works so hard to hold on to his way of life. Aboard the *Caleb*, there are no telephones, no traffic lights, no deadlines, no hurry! He has the wonders of the sky and the clouds, the wind, the sun, the moon and the stars, and the waters of the Chesapeake Bay and its tributaries, with all their moods and radiance. He has the oyster, the delicious bivalve that grows on the bottom, and he is part of this history.

103

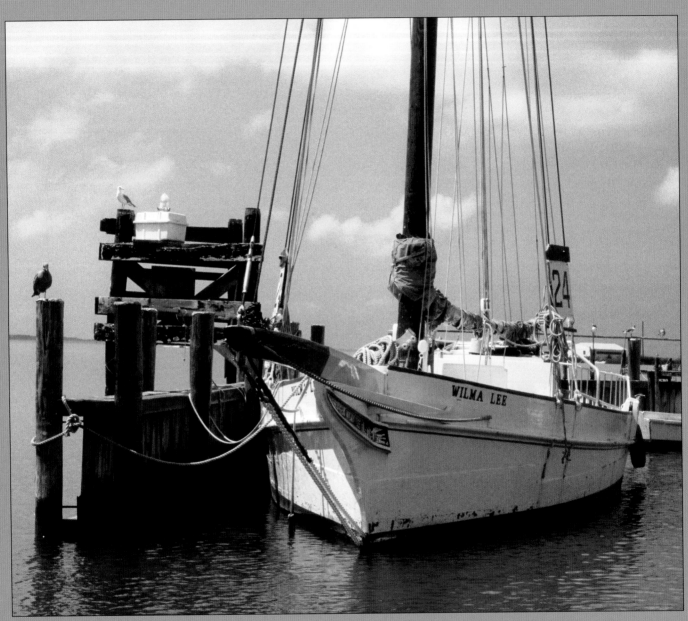

The Wilma Lee

Fourteen

Up The Mast

The weather was reasonably warm and sunny for a December afternoon. Dicky had asked Jim for some help in replacing the worn out antenna on top of the *Caleb's* mast. My continued interest was now obvious to Jim and Dicky, and I was invited to go along for the ride.

During our drive to Cambridge, my thoughts turned to the previous year when Fountain went up the mast to change the antenna. I found myself entertaining the crazy notion of asking Dicky to hoist me up to the top of the mast on the bos'n's chair to take a few pictures from a bird's eye view.

When we reached the dock, we found three Skipjacks moored together instead of the usual two. Today, *The City of Crisfield* floated alongside the *Caleb* and the *Krentz*. All three boats were tied side by side. *The City of Crisfield* was tied to the bulkhead, with the *Krentz* in the middle and Dicky's boat on the outside.

As soon as we boarded the *Caleb*, Captain Dicky readied the bos'n's chair while Jim gathered in a bucket the tools he would need at the top. After the bucket was tied to his waist, Dicky and I hoisted Jim just far enough off the deck so that the new antenna could be temporarily secured without being dragged across the deck as he was pulled up the rest of the way. When everything was in order, we hoisted Jim to the top of the mast and he went to work disconnecting the old antenna.

As usual, my eyes were drawn to The City of Crisfield, the H. M. Krentz, and the Caleb W. Jones. The mirror-like reflection on the water was as smooth as glass.

While Jim was working, I carefully considered his situation and thought it couldn't be all that bad if he could manage to stay up there for almost thirty minutes and carry out a pretty intricate assignment from that position. Surely, a couple of minutes could do me no harm. My request to Dicky was answered with a puzzled look, and he asked, "You're sure you want to?"

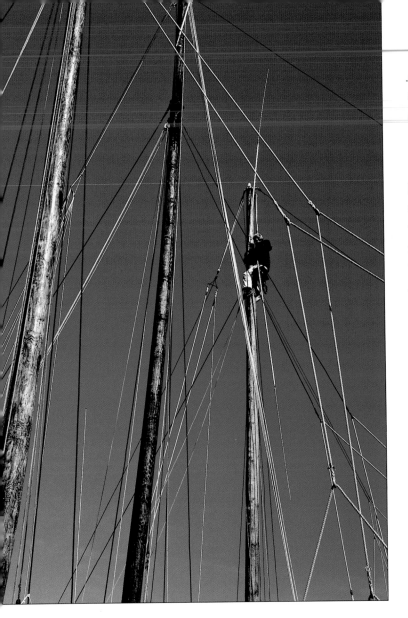

prevented me from going the final ten feet. Fifty feet in the air was high enough for me! Luckily, it was a calm day without a breath of wind. Even so, the mast swayed slightly from side to side as the current in the water flowed past the boat. I shuddered, remembering how windy it was last year when Fountain went up the mast.

There was very little room to maneuver as I looked around and reached for the camera around my neck. Directly in front of me was Clayton's Seafood Company surrounded by the work boats that supply it. Behind Clayton's I could see a few oil storage tanks.

In the opposite direction, pleasure boats of all kinds were tied in their slips. In the distance I could see the Choptank River Bridge, and the shore at the far side of the river. The Choptank was so smooth it resembled a looking glass. Unable to turn around, I never saw behind me. When I glanced down, I realized how high up I actually was, and a knot formed in my stomach. A fall from this precarious seat would almost certainly be fatal.

The *Caleb's* deck was shaded as the sun neared the horizon. From my vantage point, I could see that one of the hatch covers for the front hold was off. It looked bottomless. I could see dredges and ropes, a shovel, a few oyster shells, the dredge winder and engine box, and an old tire on the deck in front of the cabin. The boom with the white mainsail secured to it stood out in contrast.

With my camera in one hand and the rope that supported me in the other, I leaned over and peeked through the viewfinder. Unfortunately, because I was so close to it, the mast dominated the scene. The only way to compensate and possibly get a decent photograph was for me to lean out, away from the mast. After setting my camera, I did just that. I felt a sense of accomplishment and anticipated the results as I snapped off a few pictures.

"No, I'm not sure," was my reply, "but it would be an interesting viewpoint and I'd like to try it."

When he had finished his job, Jim hollered he was ready to come down, so we lowered him to the deck. He stood, and a surprised expression crossed his face when I took his place on the two-foot-long piece of wood.

"I've been thinking about going to the top of the mast ever since Fountain went up last year," I told him. "Now is as good a time as any."

On my way up, my fingers clutched the rope that was fastened to the board I was sitting on. Because the rope was passing through a pulley fastened to the top of the mast, I was pulled closer and closer to the mast as I ascended.

I was practically hugging the mast by the time I called out to Dicky and Jim to hold up. The rigging at the pinnacle

My mission completed, I signaled to Dicky and Jim, and they lowered me to the *Caleb's* deck.

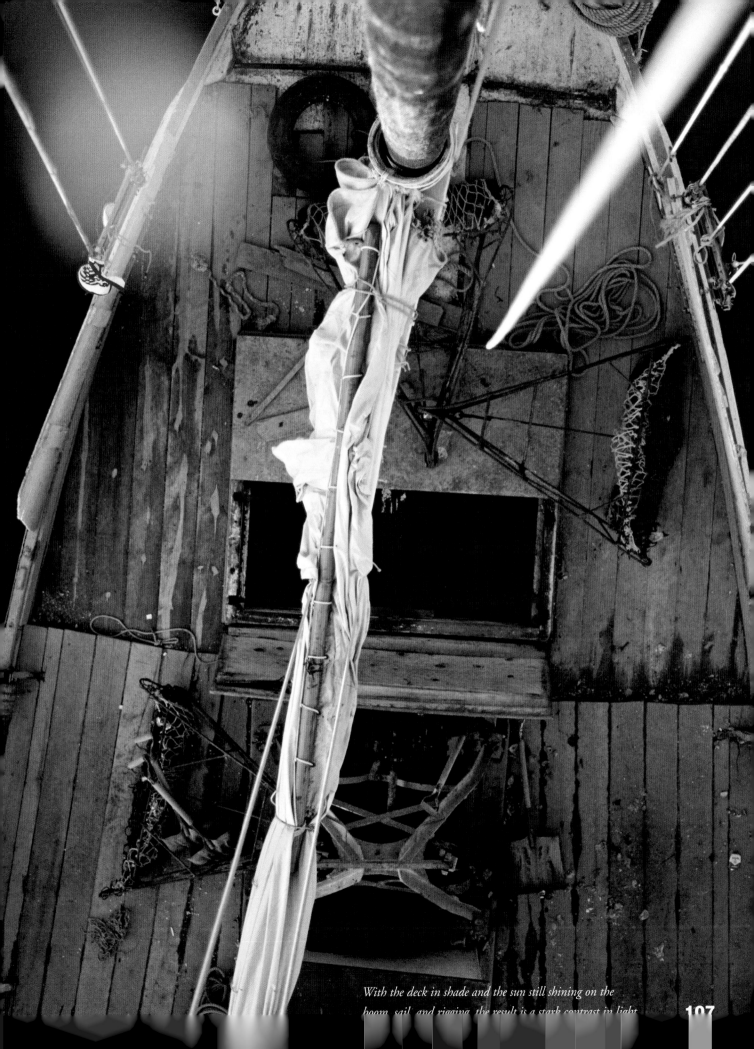

With the deck in shade and the sun still shining on the boom, sail, and rigging, the result is a stark contrast in light.

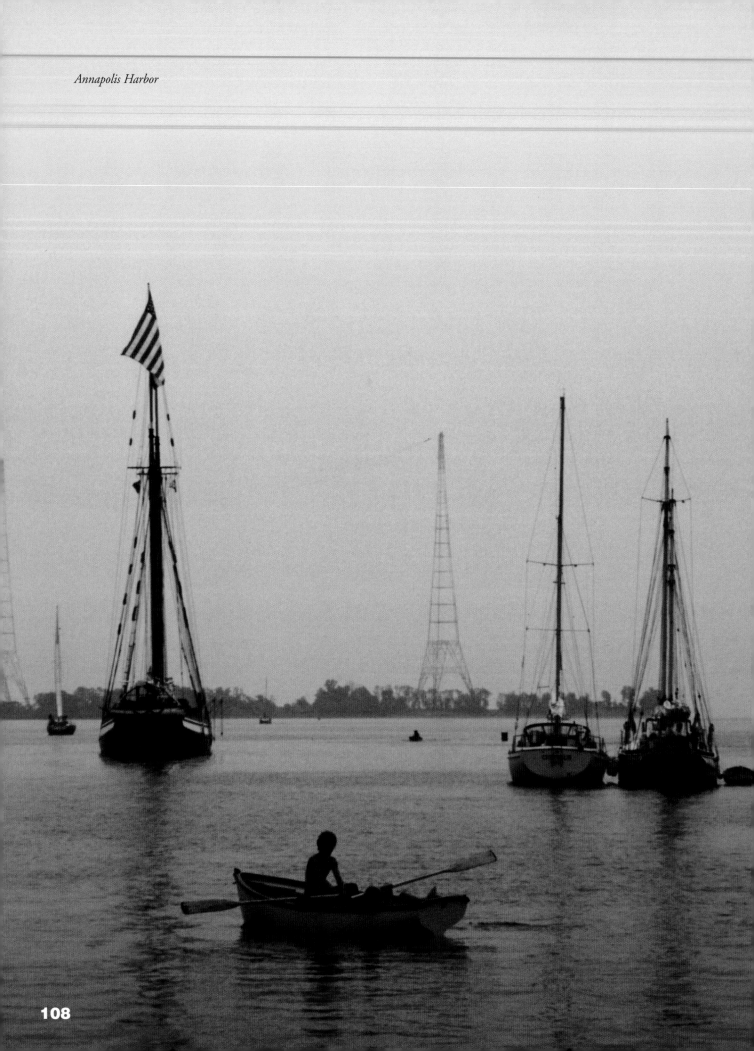

Annapolis Harbor

Fifteen

The Maryland State Boat

I was delighted when Dicky invited me to join him for a drive to Annapolis to witness the ceremony. The governor of Maryland was scheduled to formally declare the Skipjack Maryland's official State Boat. Envisioning another photo opportunity in the nautical surroundings of Annapolis Harbor, I quickly accepted his offer.

The ceremony was scheduled to begin shortly after lunch, so Dicky picked me up at around 9:00 a.m. That would give us enough time to get there, have a look around, and get a bite to eat before the proceedings began. The weather, typical for June, was warm and hazy with a chance of rain in the forecast.

After Dicky parked his truck, we walked to the harbor to see where the proclamation would take place. Intuition led us to the only Skipjack in the harbor, the *Anna McGarvey*. Dicky told me that she's owned by the State of Maryland and moored in Annapolis off season. There were some chairs and a table on deck, and an area around the

boat was cordoned off. Sure enough, we were in the right place.

Since it was still early, we strolled around the harbor and took in the sights. The harbor was filled with a variety of sailboats. We found a small seafood restaurant, and after a lunch of delicious crab cakes, we headed back to the *Anna McGarvey*. A crowd was beginning to gather. Dicky recognized a few people in the group and exchanged greetings and good will. I thought, "This man knows people everywhere he goes."

After a few minutes, the governor and his entourage arrived. It was a brief ceremony and not much was said. But, for all those in attendance, we knew something important had occurred. The beset Skipjacks were getting some recognition that just might help preserve them.

On our way back home, I thought about this dynamic man, Captain Dicky Webster. I thought about how he had nothing tangible to gain by taking the entire day off from his fishing party boat business and driving three hours to Annapolis to watch the governor sign a piece of paper. I sensed in him a feeling that, somehow, he would do anything possible to preserve his boat and his way of life.

Governor Harry Hughes declares the Skipjack Maryland's official State Boat.

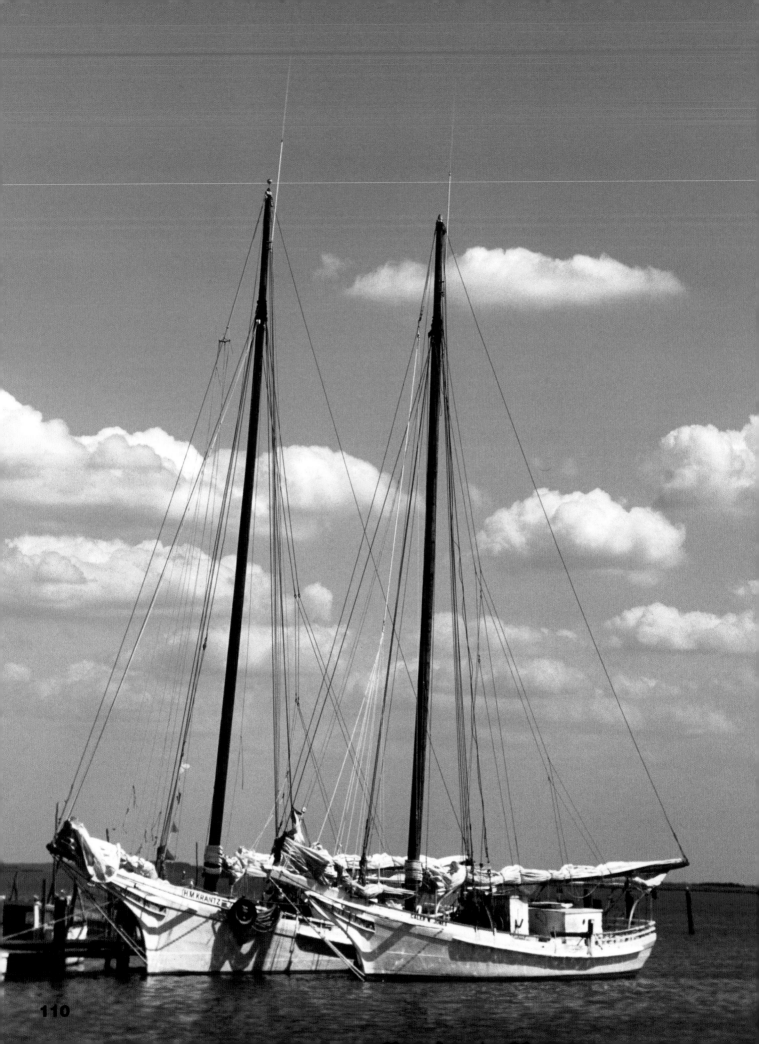

Sixteen

The Caleb and the Krentz

June, 1985. Something was drawing me to Wenona Harbor. I had to see the Skipjacks.

Having visited Wenona Harbor on other occasions, all by way of land, a tour by boat seemed appealing. I enjoy photographing my subjects from unique angles and thought this might be an opportunity to do so.

Wenona is only about ten minutes to the south of the Chance/Deal Island harbor and Windsor's Marina, where my boat, the *Cash Flow*, is moored.

The early summer day was picture perfect. The weather was warm and sunny, with blue sky and light winds. At midday I left one marina and headed south to another.

Just outside Wenona Harbor, an osprey perched on the channel marker. These magnificent birds of prey were on the endangered species list just a few years ago. Now, they have made a successful comeback and are seen throughout the bay area. The watermen call them fish hawks because they are often seen catching and eating fish, but they are better known as osprey. These large hawks bear qualities similar to those of the watermen. Both are tenacious and independent, and both are highly skilled fishermen. It is fitting that this self-appointed sentinel stands guard outside Wenona Harbor.

As I made my last turn and entered the marina, I was not surprised to see the *Caleb* and the *Krentz* moored side by side, in their usual place in the harbor.

The place was quiet. There wasn't a soul around, just boats. Since oyster season was four months away, the watermen were probably out crabbing or fishing, or they could have been finished for the day. The peaceful atmosphere calmed me, and I turned my camera to the boats.

Self-appointed Sentinel.
Just outside Wenona
Harbor, perched a-top the
buoy mariners use to locate
the channel and the harbor,
nests a family of osprey.

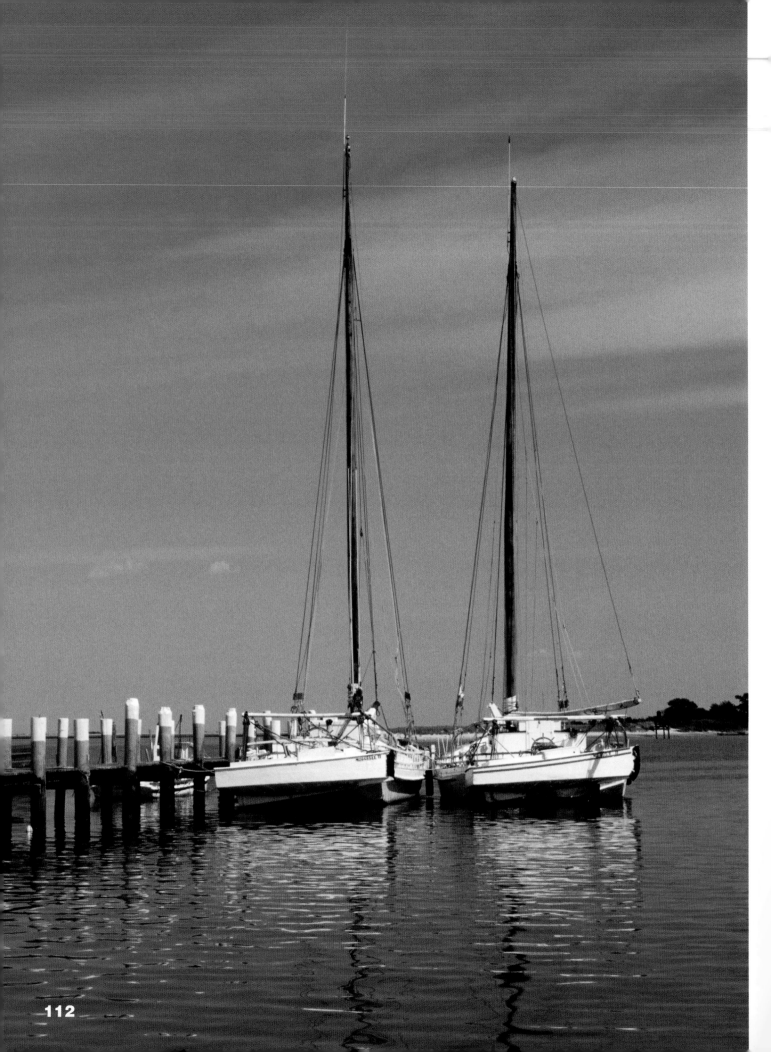

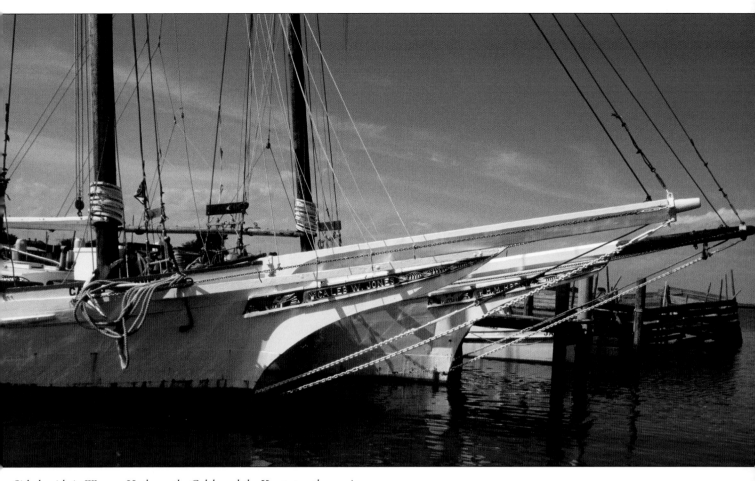

Side-by-side in Wenona Harbor—the Caleb and the Krentz together again.

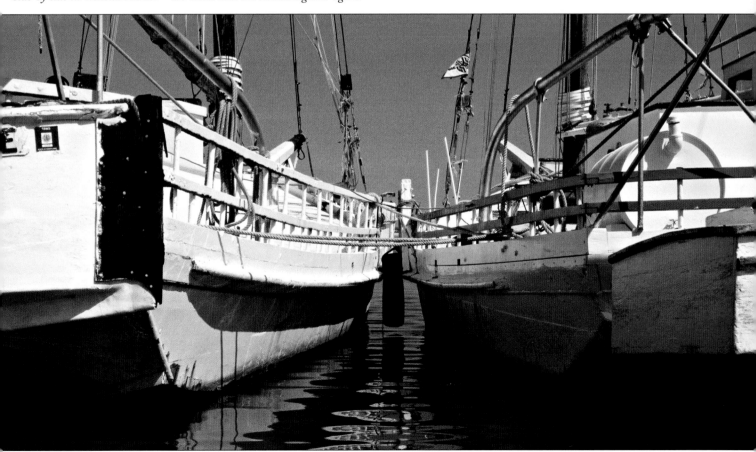

Seventeen

A Bit Of Luck

The month of September is well into the hurricane season on the east coast, and 1985 was no exception. A powerful lady called Gloria headed toward the Delmarva Peninsula and the bay. As the weathermen forecast the storm's approach, preparations were made. Several watermen and some of the Marine Police, hoping to ride out the storm in more protected waters, sailed their boats from the Deal Island area up the Wicomico River to the new Salisbury Marina. Nussie had his boat, the *Miss Julie*, hauled up and put on the bank in Scott's Cove. I loaded the *Cash Flow* onto her trailer and fastened the rig to a large tree behind the big white house at Windsor's. Dicky had recently towed the *Caleb* from Wenona Harbor to Scott's Cove in preparation for a continuance of the rebuilding work that started in 1984. He and several others who didn't have their boats hauled out of the water used extra ropes and anchors to "batten down the hatches." Because of the fury of this storm and the potential damage it could inflict, everyone was on edge.

By the time Gloria hit, everything that could be done in preparation had been. After the storm, I made my way back to the boats. Unfortunately, fallen trees across Deal Island Road, the only route leading right up to the bridge, cut off access to the island. A few days passed before I had another opportunity to check on the boats. This time, the roads were clear. At Windsor's, all was well—a little soggy, but still intact. Nussie was there. The power had gone out because of several downed utility lines, and he had to maintain a generator to keep his freezers running and his crabs from thawing. We talked for a while and he recounted how

high the water got during the storm surge. "It was over the docks and the bulkhead a right good ways," he said.

I left Nussie and went on to Scott's Cove Marina to check on the *Caleb*. Hardly anyone was around, just a few watermen checking on their boats. When I found the *Caleb*, I couldn't believe my eyes. The mast had blown over and was resting about eight inches above the new cabin. It looked as though it had been laid down gently and purposefully. If it had fallen a little lower, a lot of work from last year would have been wasted. In fact, there wasn't a scratch on the portion of the boat that was rebuilt in '84. This bit of luck was a good sign for Dicky, I thought. Indeed it was. When I spoke with Dicky a few days later, he told me that he had known the base of the mast was getting soft and needed some attention. This was one area of the boat that was scheduled to be repaired anyway. All in all, Gloria could have been much worse.

On my next visit to the *Caleb* a week or so later, she was almost unrecognizable. She was gutted from the cabin to the bow and resembled a skeleton. It was a little sad. Old wood was piled high up on the bank, next to the boat. The mast was on the bank too, revealing the base where it was soft and rotten.

Much to my regret, my time was limited during this phase of reconstruction, although I did drop by whenever possible to take some pictures and talk with the men if anybody was around. Work progressed as the main beams went into place and the new decking was started.

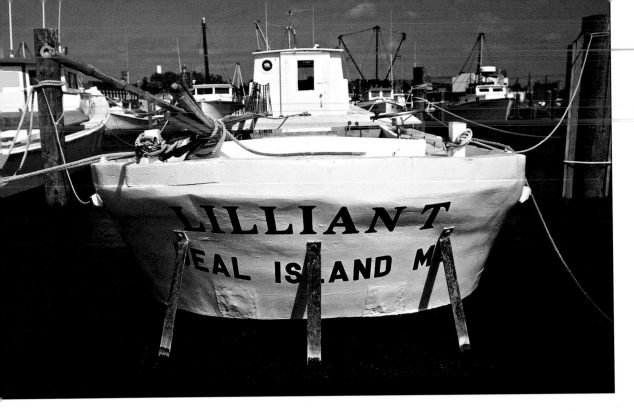

Tommy Shores of the Maryland
Department of Natural Resources
Marine Police, along with several
Deal Island watermen and their
boats, await Hurricane Gloria in
the relatively protected waters of
the new Salisbury Marina.

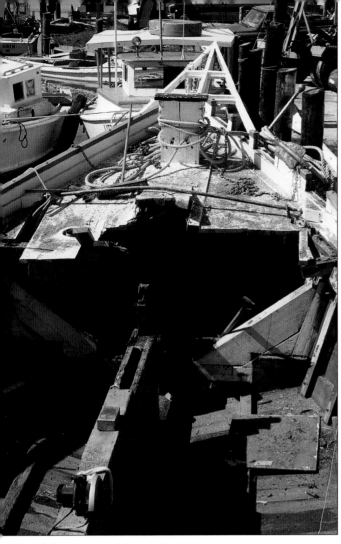

The Caleb was gutted from cabin
to bow and resembled a skeleton.

Jack uses an adhesive along with
nails to fasten the new deckboards.

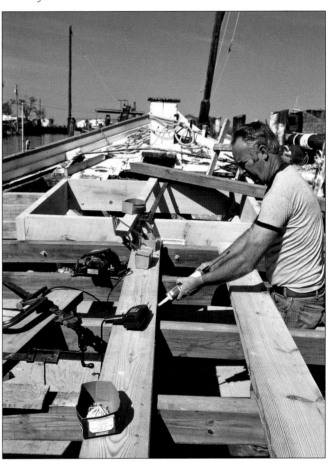

With new beams in place,
the Caleb awaits its new
deckboards.

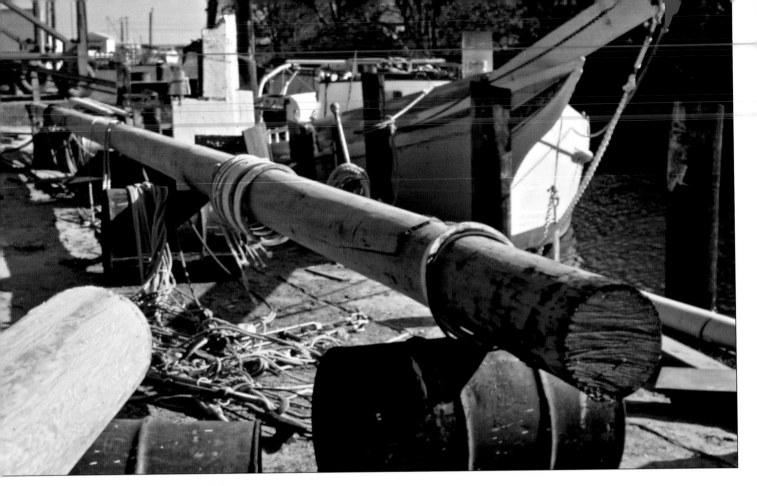

Two or three feet of the base of the mast were rotten and had to be removed.

The men bent the wood to their desired forms, following the lines of the boat. They used braces and clamps, and, inch by inch, the seemingly hard-as-a-rock oak would bend to their wills and be fastened in place. These skilled craftsmen proved themselves again, as the new decking met without flaw the decking that had been replaced the previous year.

Dicky had the new bowsprit built off-site in Cambridge, and because it was a convenient location to get the guys together, he had it delivered to my house. He forgot to tell me about it, however, so I was surprised when I arrived home after work one evening and found a bowsprit in my yard! It is a rather large piece of lumber, so when Dicky came to pick it up, he brought plenty of help. It took four guys to load it into his truck.

The task of repairing the mast remained. The bottom two or three feet were soft and had to be removed, but if this was done, it would be too short. As usual, Dicky came up with the solution. He located an aluminum cylinder about an inch thick, twelve to fifteen feet long and just the right diameter to slip over the base of the mast, thereby maintaining the mast's height. At the same time it increased its strength. As a bonus, the mast hoops then slid up and down easier.

After about three weeks of hard work, Dicky was ready for another oyster season.

The new deckboards end where the men left off last year.

They used braces and clamps, and, inch by inch, the seemingly hard-as-a-rock oak bent to their wills and was fastened in place.

Now that the new bowsprit and samson post are in place, the painting begins.

With repairs complete, the Caleb is ready for the new oyster season.

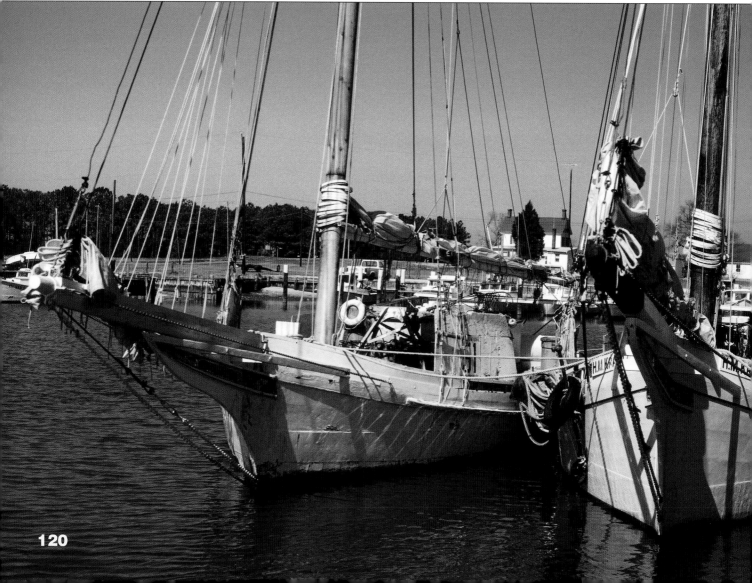

Eighteen

Tourism

By Spring, 1985, I had been exhibiting and selling my photographs of the *Caleb* and the bay for two years at various art shows throughout the Shore area and as far as Sandy Point State Park. It was May, 1985, and time for the annual Salisbury Festival held downtown. My booth was set up near the other artists in front of the old Wicomico County Court House. About mid-afternoon, a woman named Lee Whaley stopped to have a look at my work. After a few minutes, we started to talk. I briefed her on the history of the *Caleb W. Jones*, Captain Dicky Webster, and the dismal state of the oyster industry, and expressed my appreciation for and my ties to the Eastern Shore. Lee responded with an interest in and enthusiasm for my work. She reciprocated by telling me about the company she owned, Chesapeake Adventures, and the tourism packages she was putting together that were designed to show people some of the many natural and historical treasures our area has to offer. We felt a connection as we discussed the possibilities of combining tourism with

the *Caleb W. Jones* as a way to help Dicky keep his boat afloat financially. We also discovered that her husband, Donald, had been my history professor at Salisbury State College.

Some time later, I told Dicky that a friend of mine was interested in putting some tours together that involved a sailing experience aboard the *Caleb W. Jones*. Always an opportunist, Dicky seemed interested.

On Labor Day, 1985, at Wenona Harbor and with Lee's coordination, Dicky's first sailing party climbed aboard the *Caleb*. The occasion was the Deal Island Skipjack Races. Accompanying Lee and her group were some of the regulars, including me, Jim, Rodney, Bill Fritz, Steve Benedict, and of course Captain Dicky. The yawl boat was lowered in and we cast off. On our way out of the harbor, Dicky towed a Skipjack called the *F.C. Lewis* because its captain, Stanford White, didn't have his yawl boat hooked up and ready to go.

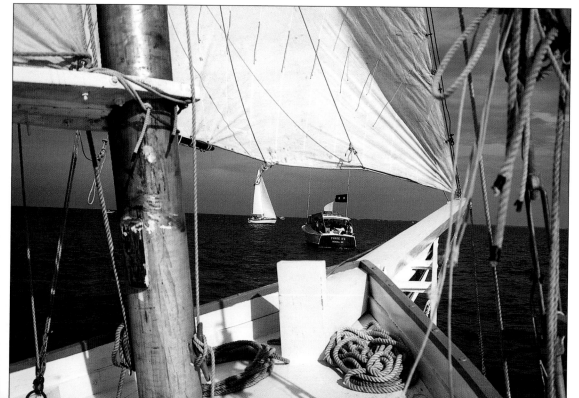

As we approach the committee boat, I realize it is the Three K's with Captain Clifton aboard.

Throughout the morning, Dicky kept everyone interested by spinning a yarn or two while sailing the boat. It must have been his years of running fishing parties that honed Dicky's communication skills. Dicky exhibited abilities as a tour guide, entertainer, story teller, historian and teacher. Maybe that is why some of Dicky's friends and peers nicknamed him George Washington Webster (shortened to just George over time). He told us about our competition (the captains and their boats), the body of water we were sailing on (Tangier Sound), and the details of the race.

It was a calm day, and the smaller, lighter boats fared better than the *Caleb*. Not only was the *F.C. Lewis* smaller and lighter, it did not have a heavy yawl boat in its davits and it carried very few passengers. Not surprisingly, the *F.C. Lewis* left us in its wake and won by a large margin. Although the additional weight from the large number of people aboard the *Caleb* impeded our progress, it really didn't matter to us or Captain Dicky. We all agreed the day was a smashing success. Our guests seemed to have had a great time, and, as usual, the crew did too. It was, however, a little ironic that we had towed the winning boat out of the harbor before the race started.

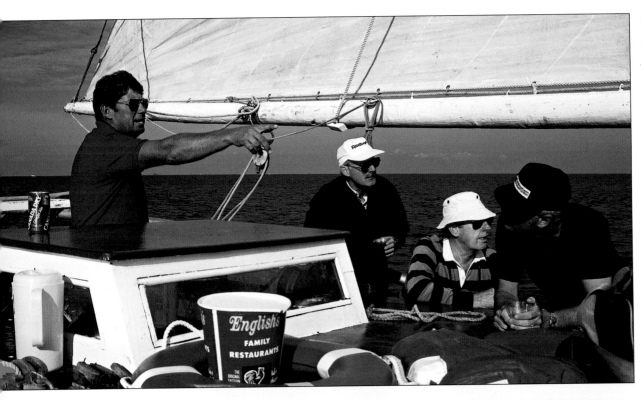

Dicky exhibited abilities as a tour guide, entertainer, storyteller, historian and teacher.

The F.C. Lewis left us in its wake and won by a large margin.

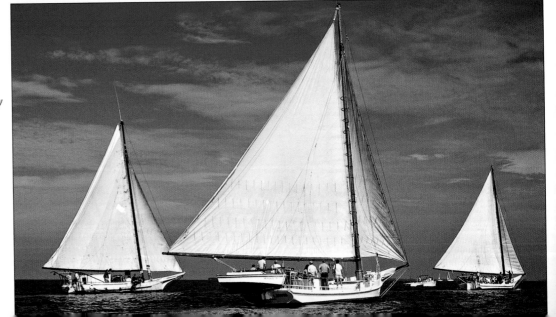

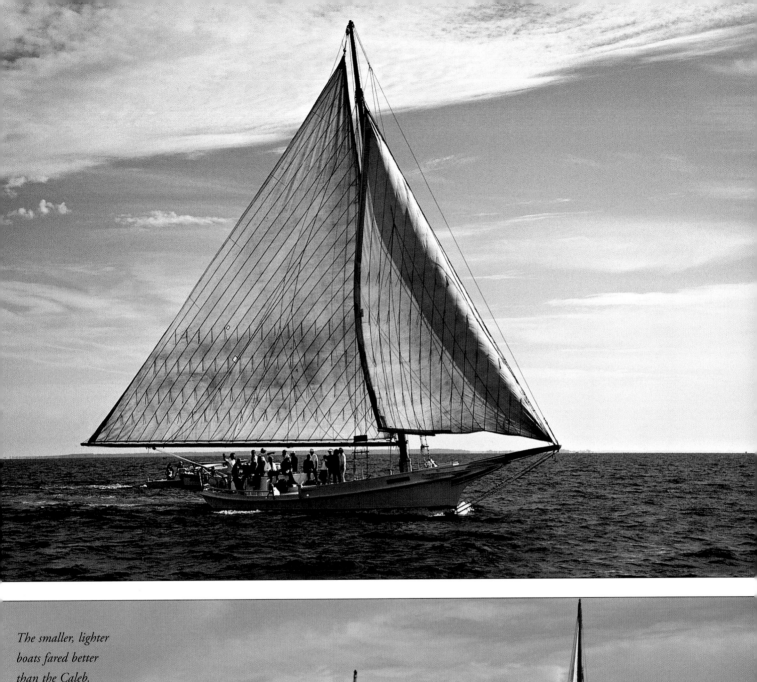

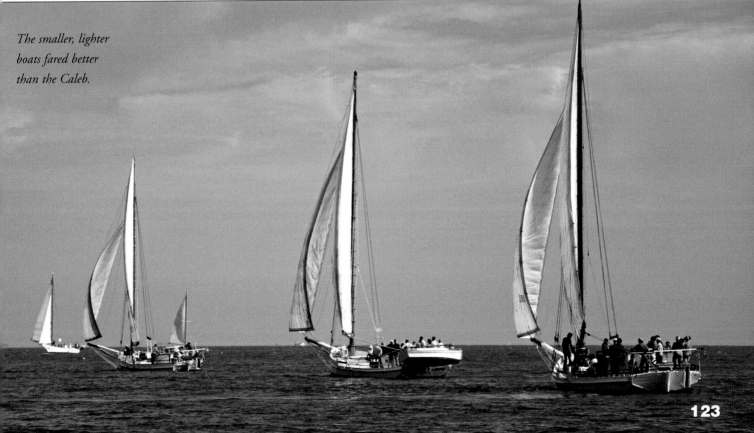

The smaller, lighter boats fared better than the Caleb.

During the following month, Lee provided some key contacts that helped further my career in photography. They ultimately resulted in exposure to groups like the Ward Foundation. In October,1985, Dicky, Lee, and I collaborated and took some members of the Ward Foundation sailing aboard Ted's boat, the *H.M. Krentz*. The *Caleb* was undergoing her second phase of rebuilding and wasn't quite ready for the new oyster season or a sailing party.

Our next sailing party occurred in September, 1986. Lee and her "Chesapeake Adventures" had a yearly outing with some people from Salisbury State College. Well, this was to be an adventure to remember. The day was gorgeous, the sky crystal clear, the temperature mild and the winds light but constant. Our destination was Smith Island, birthplace of Caleb W. Jones and home to several members of his family. We sailed across Tangier Sound, tacking to port and starboard as we went. Captain Dicky made everyone feel at home while teaching those who were interested a little about navigating the *Caleb*.

When we arrived and docked, the group disembarked and began exploring. Smith Island is a place where time seems to stand still . . . a place that is truly a window into the past, for the island has remained virtually unchanged for many, many years. A community with strong religious ties, the island is home to a number of churches. We looked around at the boats, shanties, crab pots, and dredges. There were no bars or saloons, just a quaint little street or two lined with whitewashed houses.

We settled down to a wonderful, home-cooked meal at Mrs. Kitchings' Restaurant. It consisted of crab cakes, fritters, oyster stew, fresh vegetables, homemade pies, and much more.

Our real treat of the day was meeting Caleb's wife, Charlotte, and some other family members. They appeared moved to see the boat Caleb had built and the memories it brought. Tears came to Charlotte's eyes and we were touched. The opportunity for a family picture was irresistible. There was Charlotte, two of her daughters, and a nephew, who was Jessie Brymer's son. A waterman's family.

After we said our good-bye's, we were off, headed east back to Wenona Harbor.

Not long after that trip, Lee and I changed our attitudes about introducing tourists to the Deal Island area and the *Caleb*. Because we were bringing people into places like Wenona and Smith Island, we recognized a potential problem. The very things that attracted us to these places were much more likely to change with an increase in visitors and attention. We decided that we were not ready to contribute to that change.

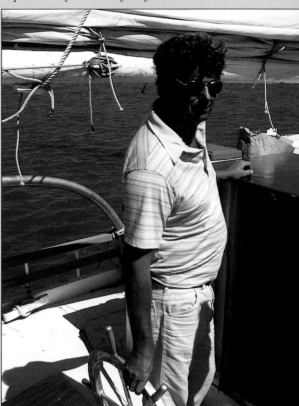

This outing with some people from Salisbury State College was an adventure to remember.

Captain Dicky made everyone feel at home.

Pictured second from left is Caleb's wife, Charlotte, with her two daughters, a nephew, and Captain Dicky.

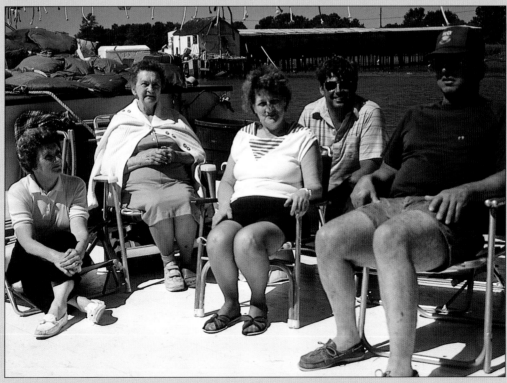

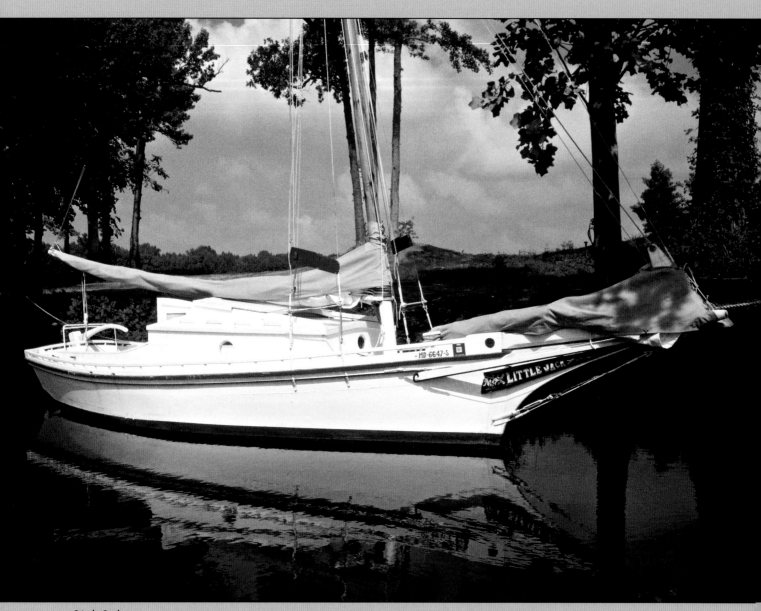

Little Jack

Nineteen

Rebuilding Yet Again — Crisfield Shipyard

Nussie calls it "Gettin' my boat put up on the bank." Dicky calls it "Gettin' my boat put up on the railway." Must be a generational thing.

For years the watermen used a marine railway to pull their boats out of the water on runners that resembled railroad tracks. In some marinas, boats are still hauled out this way. Captain Harry told me that, many years ago, there had been a railway at Windsor's Marina. Nowadays, most marinas use a large device on wheels to lift the work boats out of the water. Whatever the watermen choose to call it, once or twice a year captains have their vessels dry-docked, scraped, and painted. This is both critical and time consuming maintenance for the men who own wooden boats. It can also be expensive, depending on who does the work.

I was interested in photographing the *Caleb* while she was dry-docked, curious to see what her lines looked like from underneath. So, when Dicky called in August of 1986 to let me know he had the *Caleb* in Crisfield up on the railway, I jumped at the chance to witness on film another of the *Caleb's* rebuildings. He said, "She might have some bad boards on 'er hull that need to be replaced while she's out of the wooter." He also mentioned that he was going to meet Bill Fritz at the boatyard to determine what needed to be done.

It was late Saturday morning when we arrived. Much of the area was flooded with puddles left by a late summer rain. Except for boats of all shapes and sizes, the boatyard appeared deserted, not a soul around. The *Caleb* was probably hoisted out of the water late Friday, as she was still hooked up to the boat lift. My first impression was that she was nowhere near as pretty on land as she is on the water. The boat had been sitting all summer without much attention and was due for a face lift.

Only a few minutes had passed when Bill Fritz drove up in a black pickup truck with a dog in the back. He stepped out of his truck, and we exchanged greetings. Bill is a couple years older than I am, and grew up half a block away from me. I had known him as a kid, but I didn't know the man. So we talked about how the two of us had gotten interested in this boat, The *Caleb W. Jones*. He is a friend of Dicky's and is interested in boats in general.

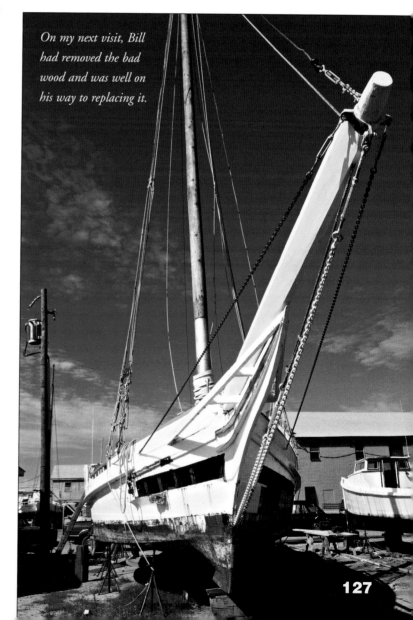

On my next visit, Bill had removed the bad wood and was well on his way to replacing it.

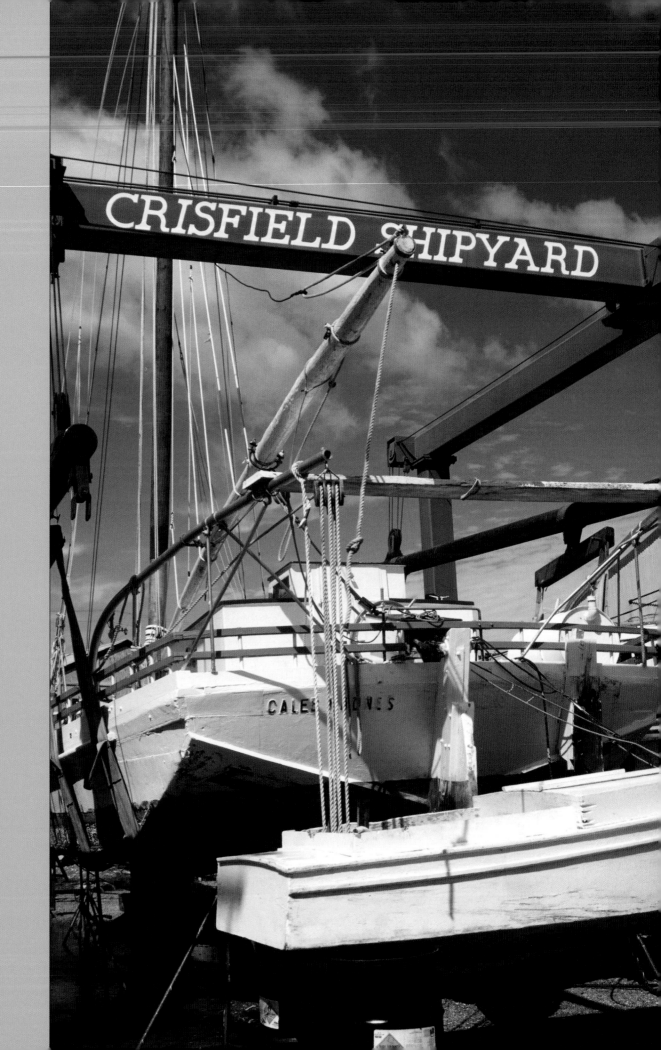

Our attention turned to the *Caleb*. Dicky showed Bill the places he already knew needed work. Then the two of them poked and prodded the hull looking for soft spots and bad wood. Someone suggested we continue the conversation over lunch at the little diner around the corner. All agreed and off we went.

On our way there, I asked Bill, "When do you plan to start the work?"

"Monday morning," he responded.

"Do you mind if I hang around a bit while you do the job?"

"Not at all, come on down," he said with sincerity.

It was Tuesday before I had an opportunity to return. The weather was warm and sunny, and the ground was beginning to dry out. The *Caleb* had been moved, but she was still easy to find because of her tall wooden mast. She had been disconnected from the lift and was now supported with a number of large wooden blocks and metal braces. Bill was there, his attention fixed on the boat.

He's about six feet tall, with broad shoulders and the beginnings of a gut. His short curly hair and mustache were well groomed. He was wearing jeans and a T-shirt, and on his feet were heavy work boots. A big pack of tobacco and a pair of glasses were stuffed into his shirt pocket. His four-legged friend was there too, patiently waiting in the back of his truck.

The work was progressing nicely. The bad wood had been taken out of the boat and Bill was well on his way to replacing it. Both sides of the stern were getting his attention. Bill showed me where he had removed and replaced some 4" x 4" posts and bracing on the inside in preparation for replacing the exterior planks. "Had to do it," he said. "You gotta have something to nail into and the old beams weren't holdin' the nails." He paused briefly and

continued. "Ya know, there's always more to it than you'd think."

"There sure is," I replied. It didn't take long for me to realize that Bill knew what he was doing as he closed in the first side. "You've been busy," I said.

"Yep, no sense in messin' 'round when there's work to be done."

That's how the day went. When I wasn't taking pictures, we talked while Bill worked. We discussed the boat and the upcoming races at Deal Island. We talked about ourselves and what we've been doing with our lives. I really enjoyed the day, and found Bill Fritz to be an interesting and colorful individual, a bit unconventional, with a good heart and great sense of humor. A sampling of his background includes living on a converted work boat and a tour of duty in Vietnam.

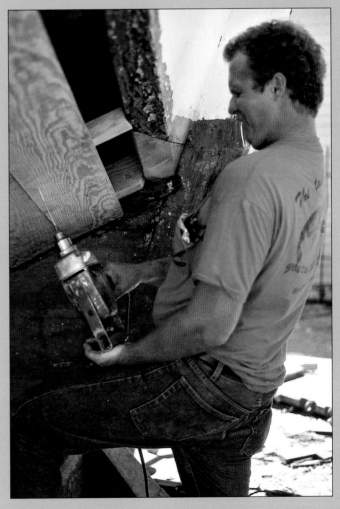

"You gotta have something to nail into, and the old beams weren't holdin' the nails."

"Ya know, there's more to it than you think."

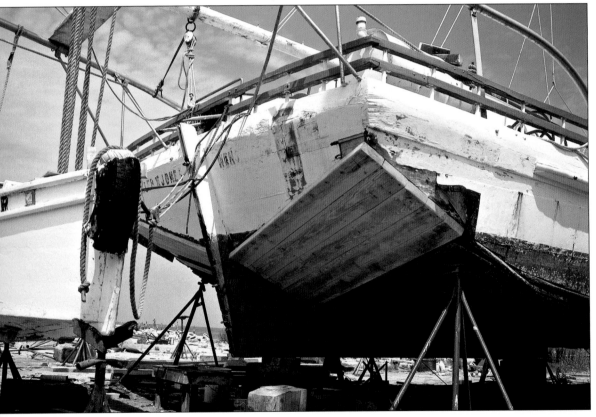

With the rotten boards replaced, the next step was to install a band of metal around the water line to protect the hull from ice damage.

Although it was built ▶ on only a small rise, Captain Clifton's house was situated on some of the highest land on Deal Island and had a grand view overlooking Wenona Harbor.

Before we left, a worker from the boatyard came over and climbed underneath the *Caleb*. He had a big roll of cotton, a hammer and a putty-knife-shaped metal wedge in his hands. Bill told me he was going to cork the bottom of the boat. After a puzzled look from me, he explained the process of driving pieces of cotton into the cracks between the planks. Then, when the boat is put back into the water and the wood swells up, the cotton helps keep the boat from leaking. I recalled an instance when Dicky had one of his crewman cork a small leak from the inside of the boat, down in the hold.

When it was time to go, I thanked Bill and told him that I hoped to see him at the races.

Twenty

Captain Clifton

One afternoon in October, 1986, I went to visit Captain Clifton Webster at his home. Although it was built on only a small rise, the house is situated on some of the highest land on Deal Island and has a grand view overlooking Wenona Harbor. Mrs. Webster met me at the door and led me to the front porch, where I finally got to meet the man I had heard so much about. Dicky had told me that his father had recently retired from running fishing parties. He did so only because he had fallen and hurt himself aboard his boat, the *Three K's*. Over the past few years, word was that Captain Clifton was one of the most successful fishing party boat captains on the bay, and, judging from Dicky's and his brother's fishing expertise, it is obvious that Captain Clifton taught them well. Only rarely does a fishing party captained by one of the Webster's of Wenona return with an empty cooler!

My first impression of Captain Clifton was that, just like his son Dicky, he was a tall man, six feet or more. Even though he now looked frail with age, it was clear that in his youth Captain Clifton had been a formidable man.

He invited me to sit down and we talked. But mostly I listened, as Captain Clifton had much to say.

I brought some of the photographs I had taken of Dicky and his boat, and handed them to Captain Clifton. We talked about my interest and concern for the Skipjacks and his way of life, and commented on how the number of working Skipjacks and their catches have dwindled over the past three years. I mentioned how enjoyable it was sailing with Dicky and how much he had taught me. While I spoke, I could almost see the memories coming back to Captain Clifton as he glanced through the pictures.

"I *love* a boat," he said.

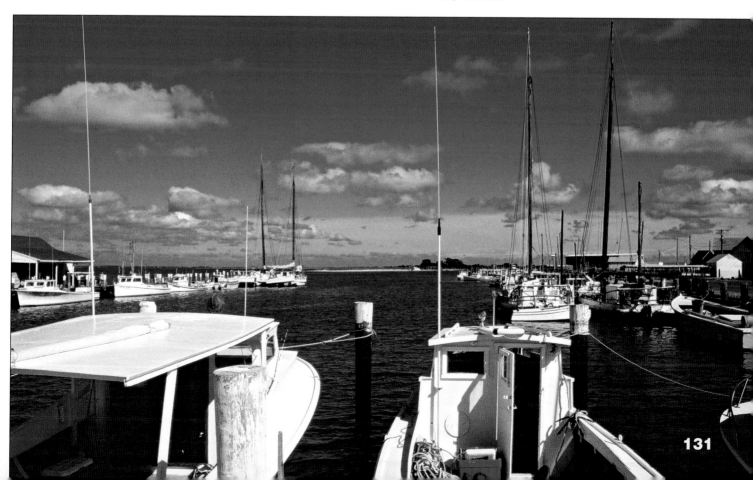

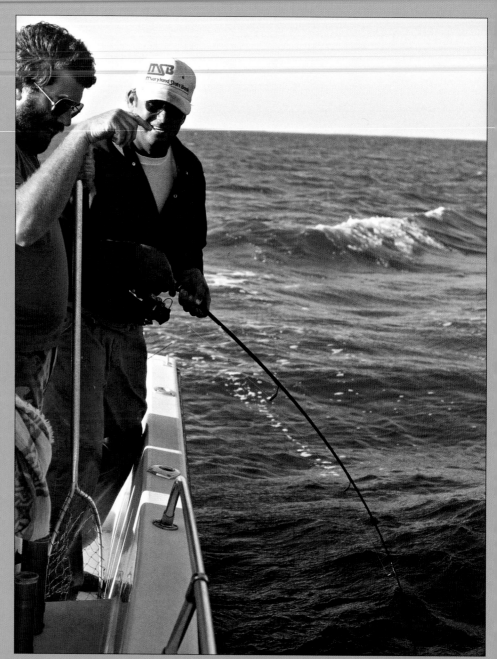

Captain Clifton told me that he had owned five Skipjacks through the years. They were the *Mary Sue, Maggie Lee, Nellie Byrd, H.M. Krentz,* and the *Caleb W. Jones.* I asked how he had come by the *Caleb.*

"I bought her for my brother-in-law 'cuz Dicky didn't. . . He was young, and he said 'Daddy, I want the boat.' Well, I let him have 'er. Yer children come first. Even 'bout yer brother-in-law. Dicky's a good cap'n. He's a good hussler. That's good.'"

"Captain Clifton, would you tell me about your family? Your father was a waterman, wasn't he?"

"My grandmother had eleven children. Six boys. The oldest was Uncle Ed. Then there was Jim, Ellis, my father, Dick Webster, Arthur, and Julius. My father was born in the yeller house down alongside this road. He taught me how to drudge and so on. I wanted to follow my father. My grandfather, he was a waterman. So that's the way it stays in the family."

"And how old were you when you started?"

"When I started, I was, uh, I think eighteen years old. My father said, 'Yer on yer own now. Let's see what you can do.' I guess I turned out all right."

Turned out pretty darn good, I thought. "So you named Dicky after your father?"

"Some called him Richard. So we named him Dicky. Dicky's pretty bright on the water. He's a good waterman and he's a good drudger. Not many beats him. Not many.

"But the trouble now—them times you could get

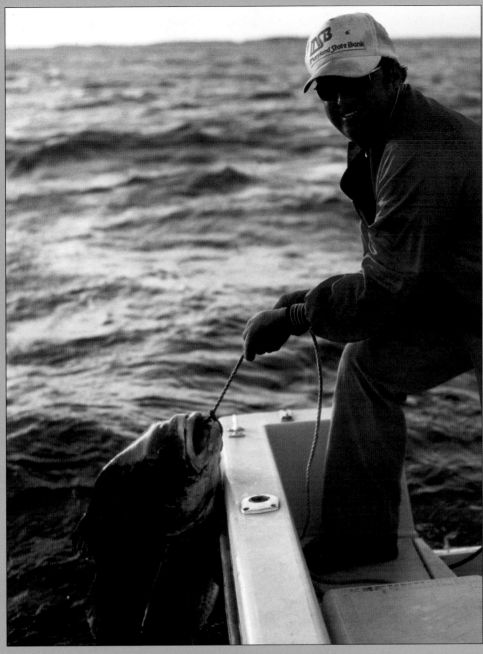

"What is it like to be an oyster dredger aboard a Skipjack?"

He paused, and his eyes seemed to focus on something far away. "It's a lot of work, ya know. You can bet yer life on that."

I had heard some stories that, in the distant past, some Skipjack captains would sail to ports of call such as Baltimore and shanghai a crew and drag them aboard, unconscious. When the men woke up, they were in the middle of the bay and were given two choices, work or swim. I also heard that after a couple of weeks, right about the time pay day rolled around, some of the captains would occasionally jibe the boom over and knock an unsuspecting crewman overboard. Well, it was difficult, but I had to ask if these stories were true. I never did get an answer, just an innocent smile.

"Which boat was your favorite?" I asked.

"The last one was my favorite. She's a newer boat. This boat was built over on the southern side of the Potomac

good men. Good crews, ya know. Not now. Not since they started patent tonging. The patent tongers get six weeks head start of the drudgers and it ain't fair."

"How did the weather affect your life of dredging oysters on the bay?" I asked.

"I've seen some rough times in this old bay and Tangier Sound. Many a time, there was neither breath a' wind on that bay. It either blows a gale or there ain't no wind at all! But, when you get older, some things change. You ain't gonna take that much chance. When I was young, I just thought I could go anytime. Now I have a lot a' respect fer it. Things has changed."

River. The feller that built her was named Krentz and he built her, and this man from Washington says, 'I'll give you $50,000 so yu'll build me one like her.' He says, 'I won't build you one for $100,000,' and he said, 'I laid in the bed a' nights and studied, and I wonderin' if I've put enough bolt rods in this boat.' Ya know, fer to hold 'er in when it got bad. Strong winds. And he said, 'No sir, I don't want ta build neither nother one.' Man, he was the particularist man there ever was. He told me he and his wife, they scraped her mast and boom, and kep' her painted just like a doll baby.

"And so I was in Annapolis and two oyster buyers was in there. One of 'em was Jessie Febuaries. I guess you heard talk of him? Well, anyhow. And another buyer from Cambridge. And he said, 'Captain Clifton, I'll tell you where a boat's at you can buy. She's practically new.' I said, 'Where's she at?' He said, 'She's in Cambridge. And the man owns her is named David Lewis. He had 'er built. So I stopped by, me and my son Ted, comin' from Annapolis that evening and we went aboard her. She was just as dry in the hole as that mat there. There wasn't a drop in 'er. I said, 'Well, she looks like she's a good quality boat." Captain Clifton paused, and it appeared as though he was looking back through the years he sailed her, and he smiled. "She was a good sailin' boat. I think I've won about seven or eight trophies since I've had her."

He continued. "So he set on that locker, this is true. When I was countin' him out a certified check, he cried just like a baby. He said, 'I would ruther part near 'bout with my wife than part with this boat.' The crew is what messed 'em up. He couldn't keep a crew for some reason. I don't know.

"Well, so we brought her on Monday morning to over on the west side of the bay, over there to the Western Shore. A place called Rod and Reel."

"They had a sea there, it opened up. And the oysters, Lord, was as big as yer hand and you could shovel 'em right from the drudge. Just two weeks I drudged there. I made enough money to pay for her. You won't do that in a hundred year no more!"

I asked Captain Clifton why he gave up dredging.

"I never had no crew," he said. "That's right. That's right. That is the reason I quit. I turned her over to Ted."

The afternoon was waning when I decided it was time to go. It seemed as though the old captain could have continued for hours on end. As I was getting ready to leave, I thanked Captain Clifton for spending time with me, and he responded, "Well, it's been nice talking to ya. I've enjoyed it!"

We said goodbye, and as I was heading for the door, I heard Captain Clifton say, "Don't let those boats go down."

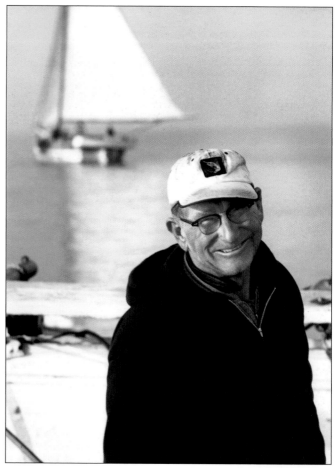

Captain Clifton
Photographer unknown

Twenty One

The Caleb Sinks

Unfortunately, by the time I realized there was much more to this story than just pictures of Dicky's boat the *Caleb W. Jones*, the opportunity to meet the man, Caleb W. Jones was gone. A month and a half short of his 100th birthday, Captain Caleb passed away. What would Caleb have said about dredging oysters with wind power aboard a Skipjack, the health of the oyster industry and the Chesapeake Bay, and the future? To me, his passing was symbolic of the dying of the Chesapeake Bay oyster industry as we know it. The 1986 season was, up to that time, the poorest oyster season since records have been kept. The official catch was listed as a meager 900,000 bushels. When compared to the record fifteen million bushels that were harvested the year before Caleb's birth, the parallels between this man's life and the rise and fall of the Chesapeake Bay oyster industry are uncanny.

On April 1, 1992, precisely one hundred and six years to the day since Captain Caleb W. Jones was born, Dicky's brother Ted was skippering the *Caleb* through the Kedges Straits, just north of Smith Island. The *Caleb* was full of oyster spat (juvenile oysters) and Ted had her headed for a predetermined location to "seed" an oyster bar. On this day, the *Caleb* never reached its destination.

It was a combination of things. It got windy. She was overloaded with spat to begin with, and she was taking on water. Then the pumps got clogged and she started going down. Just a few miles from where he was born, Captain Caleb's once prized possession sunk. Fortunately, Ted maneuvered the boat to a sandbar where she sank in only six feet of water. "The pumps got clogged and within ten minutes the water was waist deep," said Crewman Randy Webster. If the boat had gone down in the channel, she would have been lost forever and could have put the lives of the captain and his crew in jeopardy. At Arby's General store, in Wenona, friends and family spent most of the day huddled around a hand held radio listening for news and discussing the accident.

At 6:30 p.m. news arrived that with the combined help of watermen, Natural Resources Police, firefighters, and Coast Guardsmen, the *Caleb* had been raised and was on its way back to the harbor despite an approaching storm.

Within days, the Lady Maryland Foundation, located in Baltimore, offered to subsidize repair of the boat with state help and the foundation's Save Our Skipjack program. Shortly thereafter, Dicky towed the *Caleb* to Pier 5 near Fells Point in Baltimore for another chapter in his effort to maintain his boat and preserve his way of life.

By the fall of 1992, the Living Classrooms Foundation with the help of the Maritime Institute had completed the work on the *Caleb*. Captain Dicky's wife, Claudia, rechristened the boat and the *Caleb W. Jones* was hoisted by crane and lowered onto the Patapsco River.

March 1993

Captain Dicky called and invited me to sail the *Caleb* with him from Captain Clyde's Marina on the Magothy to Wenona. The season was over and he wanted to get her home.

"It will just be you and me and a reporter from the Baltimore *Sun* newspaper," he explained.

Dicky wanted to be to the boat by dawn, and it takes almost two hours to get there. Claudia drove us up and we stopped for breakfast along the way. Day was beginning to break as Claudia dropped us off and we made our way down to the boat. It was obvious the *Caleb* had been

through a long oyster season. She was messy and dirty; she had rock and debris on her deck and generally looked rough. Such is the way for a work boat. We made our preparations and, just as we were ready, our passenger arrived and came aboard. Under Dicky's direction, I jumped into the yawl boat and helped him pilot the *Caleb* out of the marina. I felt good knowing that Dicky had enough confidence in me to get in there and do the job.

During the trip down the bay, we each took several long turns at the helm. Along the way, I picked up a little more information about sailing the *Caleb*. Dicky told me how to determine what the tide was doing while we were in the middle of the bay. He said, "Sail past that channel marker and get close enough to see the currents around it. See the wake on the lee side?" There is something to be learned from Dicky every time out.

We arrived in Wenona around 5:30 p.m. and shortly thereafter, Claudia, who had gone by way of land, drove up to give us a ride home. As we walked to the car, the reporter asked me how long I had been sailing with Dicky. I avoided a direct answer, so he told me that it looked like I knew my way around the boat and had been sailing with Dicky for years. I took his remark as quite a compliment.

Summer 1993

Once again, Dicky needed an extra hand aboard the *Caleb*. He had a sailing party lined up and knew he could call on me for help. When he told me it was a wedding sailing party and that the fellow getting married used to be the Smith Island doctor, it sounded even more interesting.

The afternoon could not have worked out better. As we sailed around Tangier Sound, our passengers took in the sights and sounds while enjoying the fine food and drink they brought with them. While we sailed around, soft music played on the portable tape player. After a while, the bride and groom stood up and the preacher said some fine words and they were married in a joyful and beautiful—not to mention unforgettable—ceremony.

1993-94 Oyster Season

For the first time in generations, a Webster from Wenona was not dredging oysters aboard a Skipjack on the Chesapeake Bay or its tributaries. A noted Chesapeake Bay biologist, Dr. Robert Hedeen, believes that the large-scale commercial harvest of oysters in the bay will never recover to previous levels. Oyster harvests continue to decline and every year brings another record bad season for the watermen. And many are worried. There is talk of a moratorium on oysters in at least some areas of the bay.

Ted sold the *H.M. Krentz* a few years back, and, because of the dismal forecasts, Dicky decided to leave the *Caleb* docked while he looked elsewhere for his income. The number of Skipjacks continues to plummet. Each year more of these historic boats find their way to their final resting places. At the turn of the century, there were more than 1,000 vessels working the oyster bars; in the 1982-1983 season there were 35, in the 1992-1993 season there were 18, and, "There was only eight boats workin' up above the bridge this season," says Dicky.

Twenty Two

The Bay Today — And Tomorrow

When I spoke with Dicky about the oyster industry, he was his usual optimistic self: "The oysters are growing good in the Nanticoke River. There's small spat everywhere. If they make it through next summer, we'll do all right. The old timers say it takes seven years to come back. Next year is the seventh year."

If there is anything that I have learned from my experiences with Captain Dicky and the *Caleb* it is that the survival of the oyster, the watermen, their way of life, and their boats are intimately tied to the health of the Chesapeake Bay and its tributaries.

As more and more people learn the importance of a clean and healthy bay and its value as an economic and recreational resource, they will want to join the concerted effort of a growing number of people in the bay's watershed to be informed and involved in the painstaking endeavor to clean up and maintain Chesapeake Bay. With some creative thinking, we can continue to expand and grow without sacrificing the integrity and beauty of the world we live in.

Everyone has an impact. We can all help. Personally. Professionally.

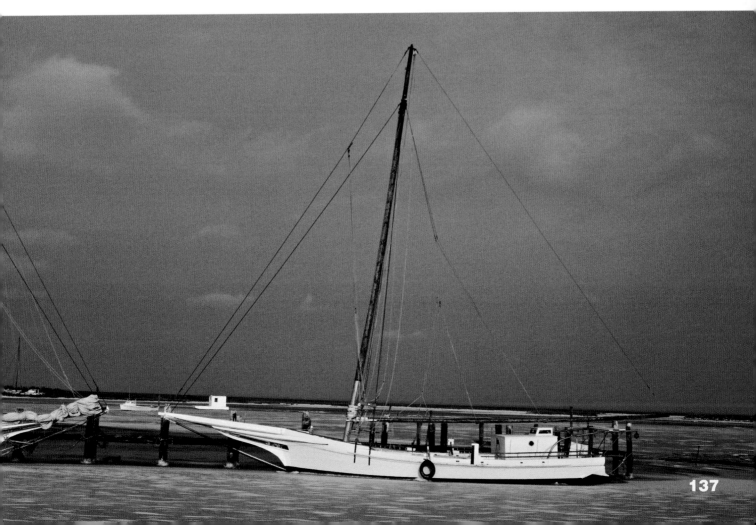

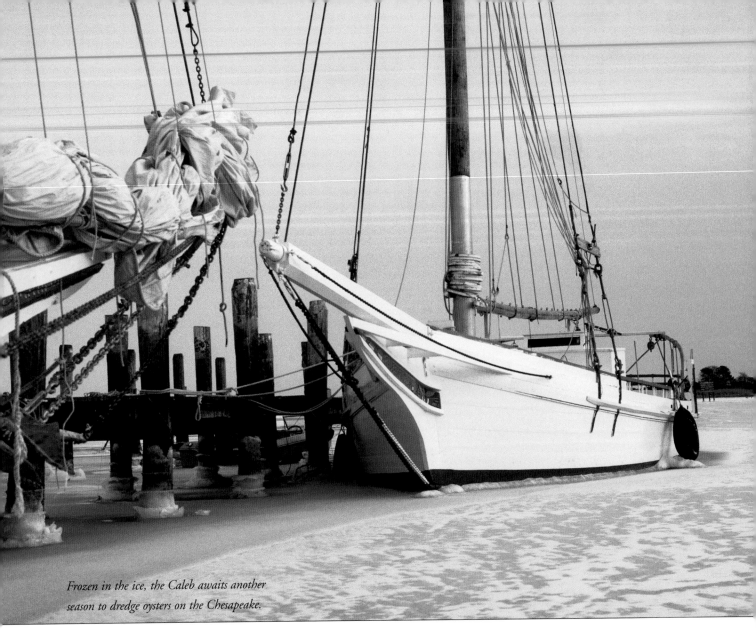

Frozen in the ice, the Caleb awaits another season to dredge oysters on the Chesapeake.

As individuals, we can start by restricting what we pour down our sinks and how we fertilize and weed our yards, by conserving and recycling, by "bayscaping" waterfront properties, and by weaning ourselves off the burning of fossil fuels. (Fossil fuels emit large amounts of nitrogen and other contaminants into the air when burned, and eventually fall back to the ground and end up in the bay.) Driving more fuel-efficient cars and trucks with higher emission standards is something we can all do. Technology is available to upgrade home septic systems with biological nitrogen removal systems. Knowledge is power, and educating ourselves about how each of us can help is paramount.

Agriculture and industry can look to developing and implementing environmentally sound ways of doing business. For example, upgrading municipal waste treatment plants throughout the bay watershed with the best technology available would greatly reduce the huge amounts of nitrogen and phosphorus entering the bay.

Some progress has been made. Eco-tourism is taking hold. This type of tourism enables people to come into an area and enjoy the natural beauty and historic treasures without destroying or changing what they came to see in the first place. This low-impact approach brings dollars

into the economy, yet helps preserve our heritage at the same time. In addition, there are a number of organizations that are working hard to protect and clean up Chesapeake Bay and its tributaries. For example, the Oyster Recovery Partnership, in conjunction with the Chesapeake Bay Foundation and the Nanticoke Watershed Alliance, are working on oyster bed reseeding projects. They are in some cases actually building artificial reefs before "seeding " them with spat oysters. The State of Maryland has oyster replenishment programs that include putting shells back into the water to rebuild bars, planting seed on those bars, and operating a hatchery on Deal Island to produce seed. Some farmers are putting into place nutrient management plans to help reduce the amount of run off from their fields into the bay. Foresters are leaving larger buffers along the watershed and developing some alternatives to how they fertilize. But, we still have a long way to go.

The population in the bay's watershed continues to grow at a very fast pace, and the pressures on the bay will continue to grow with it. The improved health of the bay is in everyone's interest. It requires a concerned public taking consistent, positive steps. It comes down to each of us making personal decisions about how we live day to day. In addition, as individuals, we each have the power to influence our government leaders to do the right thing and make the improved health of the bay a priority.

It all matters!

With a concerted effort, we can continue to witness the wonderful sight of watermen and their Skipjacks, *Workin' With the Wind* and enjoying their bounty, the oyster.

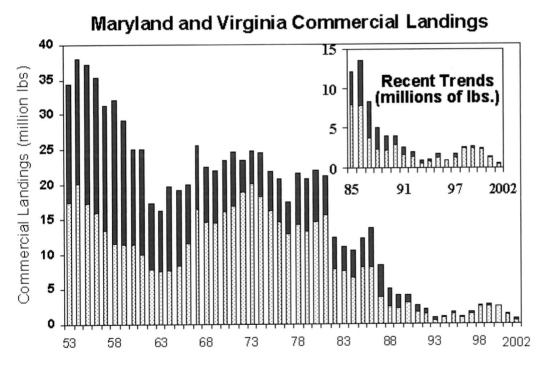

Maryland and Virginia Commercial Landings

This graph reflects reported harvest numbers by years. Oyster harvests in the bay have declined due to over-harvesting, disease, pollution and loss of habitat.

2002 harvests were approximately 2% of harvest highs in the 1950s. Two diseases, discovered in the 1950s and caused by the parasites MSX and Dermo, have been a major cause of the oyster's decline during recent times.

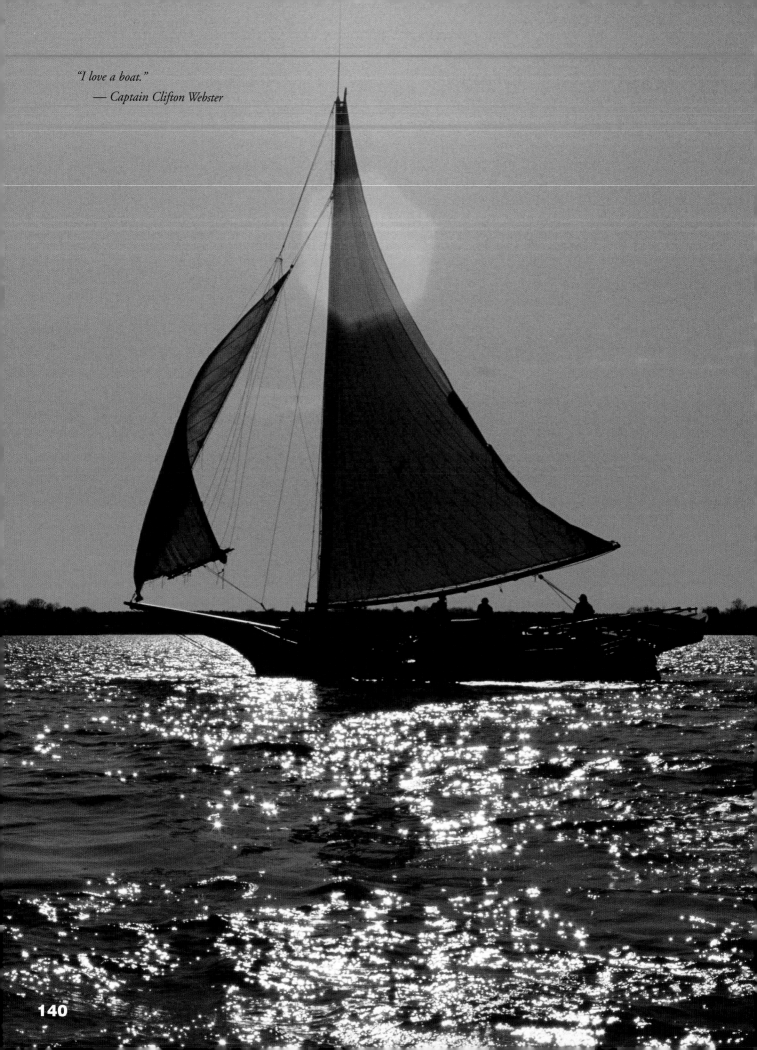

"I love a boat."
— *Captain Clifton Webster*

Bibliography

Books

Footner, Hulbert. *Rivers of the Eastern Shore*. New York: Farrar & Rinehart, 1944. Reprint. Centreville, MD: Tidewater Publishers, 1964.

Gray, Ralph D. *The National Waterway*. Urbana & Chicago: University of Illinois Press, 1989.

Hedeen, Robert A. *The Oyster*. Centreville, MD: Tidewater Publishers, 1986.

Tilp, Frederick. *Chesapeake Bay of Yore*. Alexandria, VA: Chesapeake Bay Foundation, 1982.

Tanzer, Virginia. *Call It Delmarvalous*.

McLean, VA: EPM Publications, Inc., 1983.

Warner, William W. *Beautiful Swimmers*. Canada: Little, Brown & Company, 1976.

Wennersten, John R. *The Oyster Wars of Chesapeake Bay*. Centreville, MD: Tidewater Publishers, 1981.

Newspaper Articles/Editorials

Salisbury "News and Advertiser," Robert A. Hedeen

Salisbury, MD's "The Daily Times"

Chesapeake Bay Foundation "News"

Websites

Chesapeake Bay Program, www.chesapeakebay.net

Mollies Point